AZIZ + CUCHER

SOME PEOPLE

EDITED BY
LISA D. FREIMAN

TEXTS BY
LISA D. FREIMAN
TAMI KATZ-FREIMAN
RICHARD MEYER

INDIANAPOLIS
MUSEUM
OF ART
IMA

HATJE
CANTZ

Some people fleeing some other people.
In some country under the sun
and some clouds.

They leave behind some of their everything,
sown fields, some chickens, dogs,
mirrors in which fire now sees itself reflected.

On their backs are pitchers and bundles,
the emptier, the heavier from one day to the next.

Taking place stealthily is somebody's stopping,
and in the commotion, somebody's bread somebody's snatching
and a dead child somebody's shaking.

In front of them some still not the right way,
nor the bridge that should be
over a river strangely rosy.
Around them, some gunfire, at times closer, at times farther off,
and, above, a plane circling somewhat.

Some invisibility would come in handy,
some grayish stoniness,
or even better, non-being
for a little or a long while.

Something else is yet to happen, only where and what?
Someone will head toward them, only when and who,
in how many shapes and with what intentions?
Given a choice,
maybe he will choose not to be the enemy
and leave them with some kind of life.

Wisława Szymborska, "Some People"

ACKNOWLEDGMENTS

Whenever I work with artists whom I admire, I ask them to give me a list of other artists who they believe deserve further attention. Several years ago, when working on *Team Building (Align)* with Adam Ames and Andrew Bordwin of Type A, I asked them that very question. They replied with an alphabetized list of names and websites that I investigated, person by person. In the end, the artists who impressed me the most were Aziz + Cucher, the collaborative duo comprising Anthony Aziz and Sammy Cucher. I am embarrassed to say that at that time I was unfamiliar with their work, but when I started to study it, I felt a sense of disbelief that they had not received greater institutional attention. I contacted them soon after to set up a studio visit. After sitting through an impressive presentation of their work that stretched from the early 1990s with *Faith, Honor and Beauty* up through their most recent work, *Synaptic Bliss,* I invited them to Indianapolis to see the IMA. We discussed the possibility of presenting a mid-career retrospective, but decided against it, in favor of developing a new body of work for the McCormack Forefront Galleries that would be accompanied by this exhibition catalogue. As a result of this support and encouragement, Aziz + Cucher took a sabbatical from teaching at Parsons The New School for Design and also received additional funding from Matthias Camenzind of C-Collection. They spent their nine-month residency in Israel, Palestine, Lebanon, the Balkans, and Berlin during 2009, learning more about the regions, writing a blog, and taking documentary photographs and videos of what they saw and experienced. Their goal was to take this material and transform it into a series of video-based installations that functioned as an aesthetic metaphor for the Arab-Israeli conflict in the Middle East. I think it is fair to say that the result of this investment of time and energy has exceeded all of our expectations. The work included in *Some People* is a powerful aesthetic translation of a massive amount of complex and contradictory information. Aziz + Cucher have distilled this material into a dense, yet elegantly provocative new body of work that asks many more questions than it answers. It has been a distinct honor and pleasure to work with them to complete this important project.

As senior curator and chair of the department of contemporary art at the Indianapolis Museum of Art, I am extremely fortunate that my job ensures that I am always learning and never bored. Each day is different, full of new challenges and opportunities because every artist and project presents a unique window into a world that I never could have imagined alone. Each exhibition becomes a series of new commitments and

relationships—an adventure of sorts—that requires a team of skilled people to determine how best to realize the artists' dreams.

There are many talented and committed colleagues at the Indianapolis Museum of Art who have ensured that *Some People* would be successful, particularly the former Melvin & Bren Simon Director and CEO, Maxwell Anderson, as well as the indefatigable, conscientious, and wickedly competent Kathryn Haigh, our deputy director of exhibitions and collections. Amanda York, curatorial assistant of contemporary art, is smart, efficient, and productive. Without her attention to every detail in this exhibition and catalogue, neither would have been ready for prime time. Gabriele HaBarad is a steady reality check for all of us on an ongoing basis. She is, quite simply, the best department coordinator I will ever know and I am grateful for her devotion, determination, clarity, and support. Brad Dilger is a quiet, modest miracle-worker who deserves praise for his ability to resolve video problems before they even emerge. Our video installations continue to be among the most elegant ones in the country, thanks to his prowess. Our installation crew—Mike Bir, Mike Griffey, Marc Anderson, Derrick Method, Andy Stewart, and Scott Shoultz—is remarkable and I am grateful to all of them, including their boss, IMA chief operating officer Nick Cameron, who is always wise and helpful. My gratitude extends to many others: in the design department: Laurie Gilbert, Matt Kelm, and Lara Huchteman; in publishing and media: Tascha Horowitz, Rachel Craft, Emily Zoss, Julie Long, Tad Fruits, Katelyn Harper, Daniel Beyer, Emily Lytle-Painter, and Emily Farra; in exhibitions and registration: Kayla Tackett, Brittany Minton, and Anne Young; in public affairs: Katie Zarich and Meg Liffick, Jennifer Anderson, Candace Gwaltney, and Maureen Brierton; in finance: Jennifer Bartenbach, Pam Graves, and Justin Granger; in administration: Lauren Amos; and all of the people in visitor services, security, and housekeeping.

I also would like to thank our catalogue contributors. Tami Katz-Freiman (who incidentally is not related to me in any way) wrote a brilliant, thoughtful, and important essay on Aziz + Cucher's work. Formerly chief curator at the Haifa Museum of Art, she has been their champion and friend for well over a decade, and her long-view perspective adds great depth to our understanding of their work. Richard Meyer, associate professor of art history and fine arts at the University of Southern California, has known Aziz + Cucher since they met in San Francisco in the early 1990s. His interview helps readers to better understand the relationship of the new work to many of their earlier projects. I am grateful to both Katz-Freiman and Meyer for their willingness to contribute their ideas to this catalogue.

Thanks to Anja Lutz and all the people at Hatje Cantz: Sandra-Jo Huber, Katja Jaeger, Cristina Steingräber, and Julika Zimmermann. Generous support for the catalogue was provided by the Elizabeth Firestone Graham Foundation.

I would be remiss if I did not thank my family—Ed, Michaela, and Tess—who always support my adventures and passions, even when they are sometimes inconvenient.

LISA D. FREIMAN

First and foremost, we would like to thank Lisa Freiman for giving us the extraordinary opportunity and challenge to go freely into untested territories. This project could not have been possible without her passion, her faith in our vision, and her encouragement. It has been a real gift to collaborate with Lisa in bringing this work to life. Moreover, we are in awe of the intellectual prowess she has displayed in writing a fantastic essay that captures the elusive yet indelible thread that runs throughout all our work.

Thanks to Maxwell Anderson, who responded so positively to Lisa's initial proposal for *Some People* while he still held the directorship of the IMA.

Additionally, we would like to thank Amanda York and Gabriele HaBarad in the department of contemporary art at the IMA, as well as Brad Dilger and the whole crew for managing the technical complexity of our installation. Thanks also to Rachel Craft and Tascha Horowitz along with the staff of the publishing and media department at the IMA for making this book possible.

Thanks to Richard Meyer for the engaging, insightful, and utterly enjoyable interview that we had together. We appreciate how he has been able to acknowledge the continuity of our relationship as it pertains to the creation of our work throughout these many years.

Tami Katz-Freiman has been a loving friend and trusted adviser since meeting in 1998. Without her help with the logistics of our trip to Israel in 2009, none of this work could have been completed. More importantly, we are profoundly thankful for her contribution to this catalogue, which brings a much needed "insider" perspective on our work and delves deeply and thoughtfully into the often fraught relationship between art and politics.

A big thank you goes to Adam Ames and Andrew Bordwin of Type A for aligning the stars and bringing Lisa into our midst.

Sven Travis, Simone Douglas, and Tim Marshall from Parsons The New School for Design in New York, where we are employed as faculty, have been exceptionally generous in their support of our work over the years and we are grateful for their continued commitment and friendship.

A very special thanks goes to both Maya Lipsker and Pedro Osorio, our "moving muses," who worked so passionately to help us realize our vision in a field that we were trespassing into.

Finally, we must express our heartfelt thanks to Matthias Camenzind, who early on recognized our need to make this work and provided the more-than-generous support that gave us the freedom to experiment and develop the foundations of *Some People*. Meeting him when we did was pivotal, and we are profoundly grateful for the intensity of his enthusiasm.

AZIZ + CUCHER

9

LISA D. FREIMAN

TURNING ON ITS OWNERS: AZIZ + CUCHER'S SPATIAL UNCANNY

. . . for this uncanny is in reality nothing new or alien, but something which is familiar and old-established in the mind and which has become alienated from it only through the process of repression. . . . the uncanny [is] something which ought to have remained hidden but has come to light.

Sigmund Freud[1]

We all live with a constant barrage in the media of graphic images about war and violence in the Middle East, which paradoxically have desensitized us to the human dimension of the conflict. As artists, it is impossible to compete with the spectacle of the media, but it is possible to attempt to create a poetic vision that depends more on allusion and nonlinear thinking, rather than on fidelity to a documentary truth.

Anthony Aziz and Sammy Cucher[2]

After twenty years of working and living together, the collaborative duo Anthony Aziz and Sammy Cucher continue to address the major dilemmas of our time through large-format, digitally enhanced photographs and video installations. Living in New York during the aftermath of 9/11, Aziz + Cucher have tackled a pressing historical subject that few artists have had the desire or convincing aesthetic ability to confront—the ongoing and relentless violent engagements between Israel and its Arab neighbors. Both artists have familial and cultural roots in the Middle East. As confirmed Zionists, Cucher's entire family recently immigrated or made *aliyah* to Israel, and his nephews serve in the Israeli army; Aziz, meanwhile, has cousins and extended family living in Lebanon. After witnessing firsthand the terror of 9/11 in New York, as well as the subsequent barrage of re-presented media images of violence related to the Middle East, they began to feel that they could no longer remain silent as artists and needed to confront the historically endless cycle of human self-destruction. The new body of work that they have created in response to this subject—*Time of the Empress, In Some Country Under a Sun and Some Clouds, A Report from the Front,* and *By Aporia, Pure and Simple*—represents a powerful aesthetic response to this seemingly unexpected personal recognition—one might even say it characterizes a psychoanalytic working through of the artists' own histories—after a career in which they have mostly distanced (or repressed) overt consideration of their personal identities in their work.

This personal repression is not surprising given the critical and historical exhaustion with political art after the rise of feminist art, queer art, black art, and multiculturalism between the 1970s and mid 1990s. After the 1993

Whitney Biennial, which infamously privileged identity politics, there was a profound backlash against personal or political work; many artists subsequently avoided it because this subject matter was suspect. In *Time* magazine, Robert Hughes called the 1993 politically correct Whitney Biennial a "fiesta of whining,"[3] and although Roberta Smith was more generous in *The New York Times,* she admitted that "there are only a few instances where the political and visual join force with real effectiveness."[4] The Whitney Biennial eventually became a temporary bookend for socio-political art, a cautionary tale for artists.

The 9/11 terrorist attacks created a dire breach in our understanding of the basis of our reality as Americans. In the years since 9/11, artists have gradually been responding to this historic break, and as recently as July 2011, MoMA PS1 featured one of the first major museum exhibitions that, according to curator Peter Eleey, "aims to think about how 9/11 continues to shape how we see the world retrospectively."[5] Literary theorist Brian Jarvis has written about the aftermath of 9/11—its senselessness, how it subsequently became a "black hole of meaning, impossible to escape."[6] He explained, "As the urban uncanny, Ground Zero may thus be described as a space full of unknowing, a locus haunted, in Wallace Stevens's chilling phrase, by the 'nothing that is not there and the nothing that is.'"[7] Jarvis goes on to discuss how Ground Zero and its consequent unrepresentability has become associated with the literature of trauma. He explains, the "*ur-text* is the Holocaust, [and] the radical negativity of trauma is often mirrored in writing that circles around its own impossibility and seeks to refuse the 'obscenity of understanding.'"[8] Aziz + Cucher recognized the danger and difficulty of creating work that addressed

historical trauma—in this case the long-standing Arab-Israeli conflict—as well as their doubly problematic position as outsiders trying to comment on this very context, but by 2006 they had reached a point of no return: they were ready not only to take on the struggle full-force, but they were open to considering their complex personal relationship to it in their work.

This essay offers one reading of their poetic interpretation of the conflict, suggesting that *Some People* can be understood, at least partially, in relation to Anthony Vidler's contemporary "spatial" or "architectural uncanny." In his book, *The Architectural Uncanny: Essays in the Modern Unhomely,* Vidler describes the uncanny as a metaphor for a certain "unhomely" modern and postmodern condition denoted by estrangement, temporal anxiety, the repeated return of the past, and alienation. He bases his discussion of the uncanny on Freud's 1919 essay, "The Uncanny," which grew out of Freud's wartime interest in psychiatric trauma victims. Vidler explains, "For Freud, 'unhomeliness' was more than a simple sense of not belonging; it was the fundamental propensity of the familiar to turn on its owners, suddenly to become defamiliarized, derealized, as if in a dream."[9] What seems important here for Aziz + Cucher's new body of work *Some People* is how Vidler's understanding of the Freudian uncanny is tied to the "barbaric regression" of Western civilization after World War I. That war, and too many others to name here, have produced extreme social anxiety and dread, literally disrupting many cultures and landscapes. Vidler subsequently argues that the modern uncanny did not relate solely to a house or even a city, but defied boundaries, extending throughout the countryside and into the realm of the psychological landscape, essentially leaving nowhere untouched. Vidler

suggests that the modern condition was thus defined by a "transcendental homelessness" that resulted from ongoing war, uprooting, exile, forced nomadism, and nostalgia for a "true, natural home."[10] He goes on to describe the postmodern, poststructuralist, or contemporary architectural uncanny as something that is "ambiguous, combining aspects of its fictional history, its psychological analysis, and its cultural manifestations."[11]

The four video installations that comprise *Some People* are non-narrative, but additive, and together they conjure a totalizing, tumultuous, absurd landscape simultaneously representing the past and present, creation and destruction. Throughout the exhibition, the viewer teeters on reality and unreality, on dreams and the everyday, on the common and the strange. The installations here—which fuse elements of documentary photography and video, drawing, animation, choreography, sound, performance, costume design, and theater—each exist individually but together form an overarching metaphorical and psychologically-inflected landscape that invokes Vidler's spatial uncanny.

Aziz attended Boston College, graduating with a BA in philosophy in 1983. Afterwards, he studied art, art history, photography, and cinema for four years on a part-time basis at Boston's School of the Museum of Fine Arts and Massachusetts College of Art and Design, and took classes at an independent artist-run cooperative called the Boston Film / Video Foundation. He later earned an MFA at the San Francisco Art Institute in 1990. His earliest passion was documentary film and that focus led him to study non-traditional photography. In graduate school, he made large-format photographic and text projects focused on the themes of masculinity and power. His work was influenced by feminism and the politics of

representation, as well as the impact of AIDS on sexual desire.[12] Aziz met Cucher at his MFA thesis show in May of 1990. He was exhibiting a series of work called *Public Image / Private Sector* in which he included twelve life-size photographs of older white men first in their formal corporate attire and then naked figs. 1–2. The associated black text panels listed the men's age, height, weight, firm, position, annual corporate sales, number of employees, and number of children, along with a personal statement fig. 3. Cucher was so enamored with the show, he asked a mutual friend to introduce him to Aziz. Soon after they became a couple and began working together.

Cucher received his BFA in 1983 from Tisch School of the Arts at New York University where he studied experimental theater and participated in New York's avant-garde theater scene until 1985. He explained: "I wanted to create non-linear operatic masterpieces involving music and visuals. Then I went back to Venezuela where I met a number of people in the visual arts who were experimenting with video. I started to work with narrative in video but then the video work became installation, and it jumped into a non-theatrical gallery space."[13] Four years later, he left for the San Francisco Art Institute where he focused on video art and received his MFA in 1992.

The architectural uncanny has been a continual presence throughout Aziz + Cucher's work since they burst onto the art scene in San Francisco as a collaborative in 1992. Their photographic series *Faith, Honor and Beauty* (1992) depicted idealized frontal nudes holding iconic props including machine guns, laptop computers, and babies figs. 4–7. Standing against patriotic backdrops in solid blue or red, the isolated Social Realist-inspired portraits recalled classical Greek and Roman sculptures with a twist. Using what was then the new, mostly

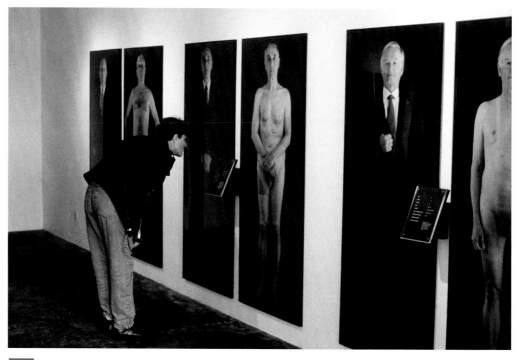

fig. 1
Anthony Aziz, *Public Image / Private Sector,* 1990
As installed at the Los Angeles Center for Photographic Studies (LACPS)

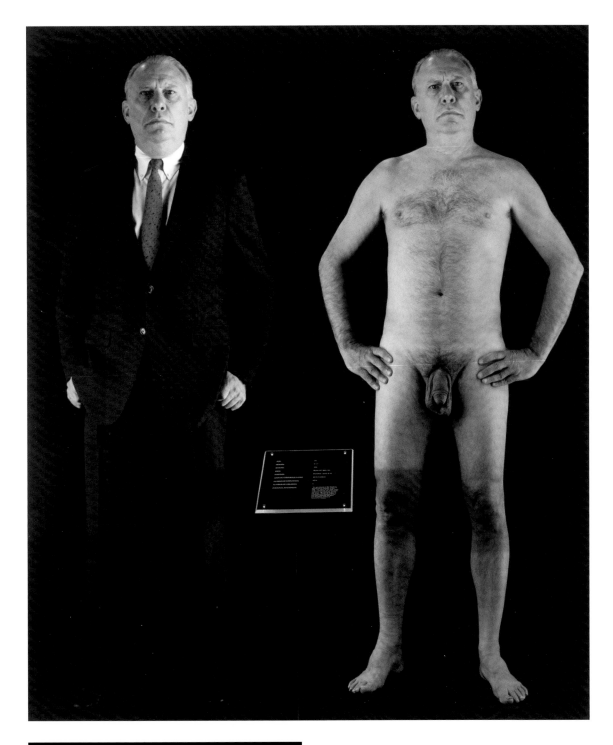

AGE:	52
HEIGHT:	5'9"
WEIGHT:	163
FIRM:	Lexall Industries
POSITION:	Executive Vice President
ANNUAL CORPORATE SALES:	$1.2 billion
NUMBER OF EMPLOYEES:	12,450
NUMBER OF CHILDREN:	4
PERSONAL STATEMENT:	"Our immediate goal is to play hard Ball with the big guys by Strengthening our financial base. Currently we are implementing Aggressive strategies to effectively and efficiently keep pace with the complicated modern society in which we live. Interfacing with our clients and personnel is what we seek to achieve."

Top:

fig. 2

Anthony Aziz, *Public Image / Private Sector,* 1990
C-print diptych with text panel, 72 x 60 in.

Bottom:

fig. 3

Anthony Aziz, *Public Image / Private Sector,* 1990
Detail of text

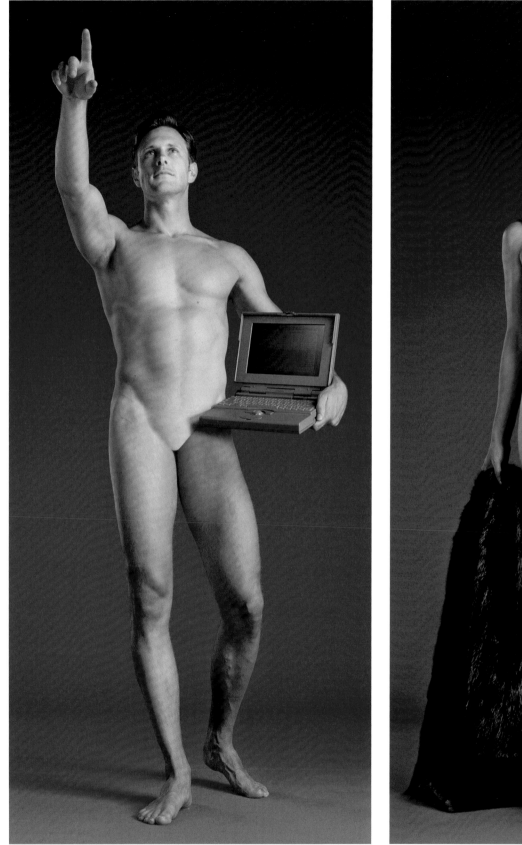

figs. 4–7

Faith, Honor and Beauty, 1992
C-prints, each 86 x 38 in.

18

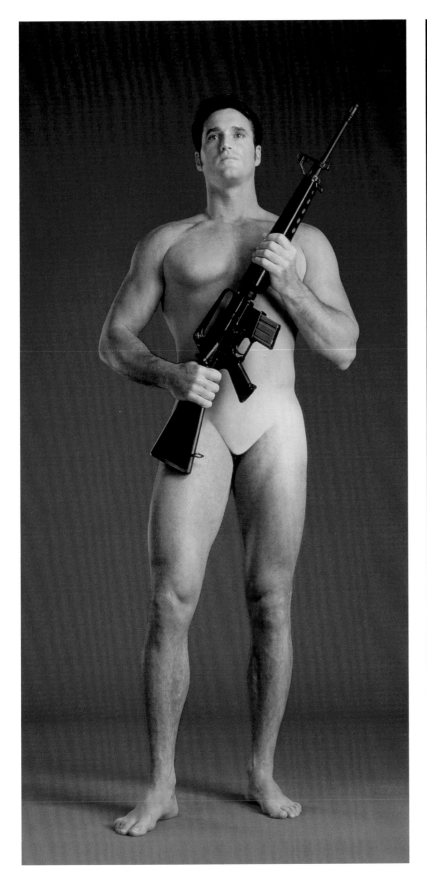
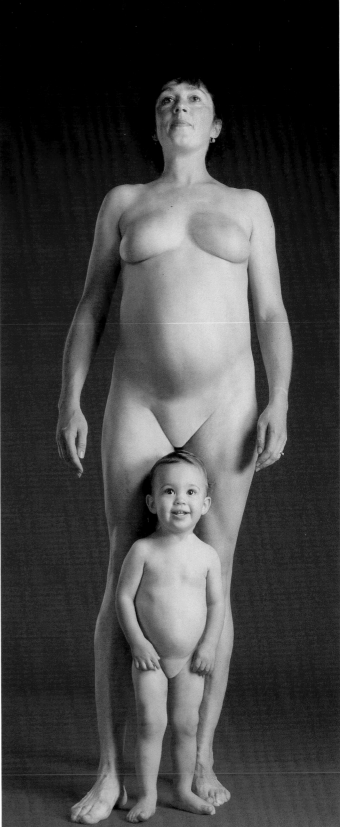

untested Photoshop technology, Aziz + Cucher erased the male and female genitalia of the heroicized figures, leaving their sexual characteristics absent. The subsequent portraits evoked both the rising role of technology and the complex censorship battles that were looming large in the world of art and politics, most notably in relation to "the NEA Four"—Karen Finley, John Fleck, Holly Hughes, and Tim Miller—who sued the National Endowment for the Arts over its decency clause. But in addition to commenting on recent historical events, these idealized nudes resurrected styles associated with various past moments in art history, and as a result they produced figures that were uncannily familiar, yet strangely alienated from the real. These were ambiguous figures, portraits of instability and anxiety that also alluded to the growing influence of biotechnology and bioethics.

After the success of *Faith, Honor and Beauty,* the artists pushed their ideas about erasure and censorship in the related series *Dystopia* (1994–95), which consisted of large, color headshots of men and women with their eyes, ears, noses, and mouths digitally erased `figs. 8–11`. The unnerving portraits, described by one critic as "postapocalyptic meltdowns," not only depersonalized their subjects, but pointed to censorship, invisibility, the increasing reach of technology into our daily lives, and the body as an unhomely container, estranged from and closed off from itself and the world.[14] *Plasmorphica* (1996–97), another series that includes six C-prints and a mixed-media installation of fifteen totemic "plasmorphica poles," pushed bodily defamiliarization to epic proportions. Aziz + Cucher made over 100 casts of electronic devices that had bodily relationships like computer mice, Game Boys, remote controls, and telephone handsets.

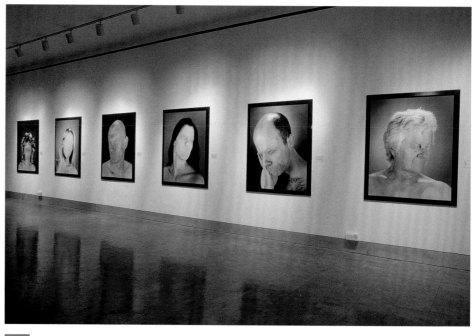

`fig. 8`

Dystopia, 1994–95
As installed at Friends of Photography /
Ansel Adams Center, San Francisco

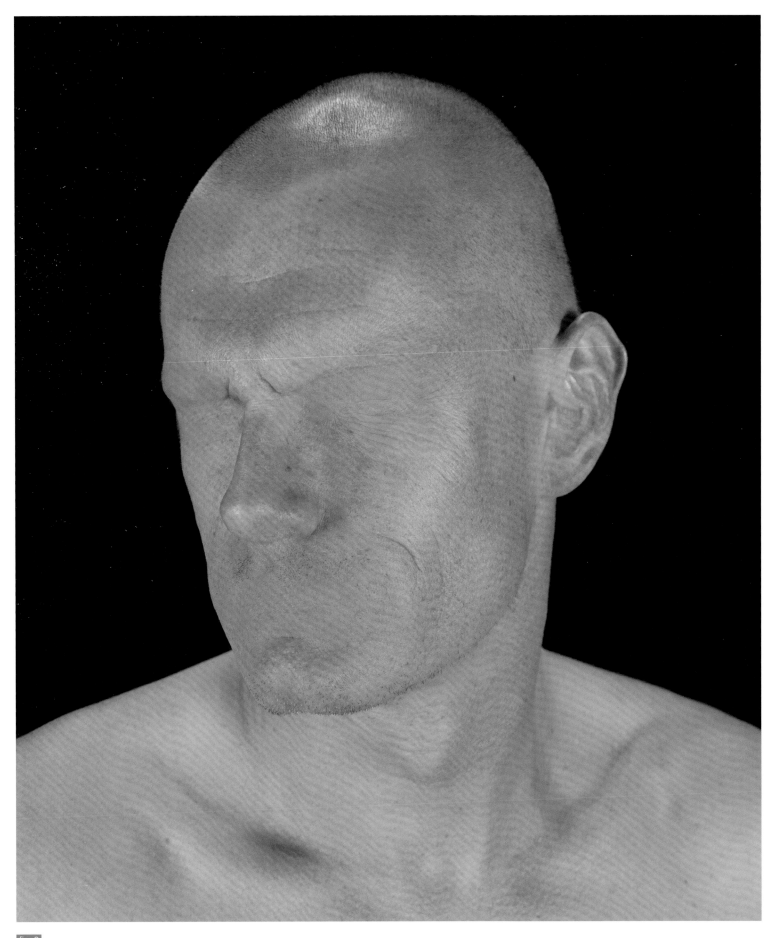

Chris from the *Dystopia* series, 1994–95
C-print, 50 x 40 in.

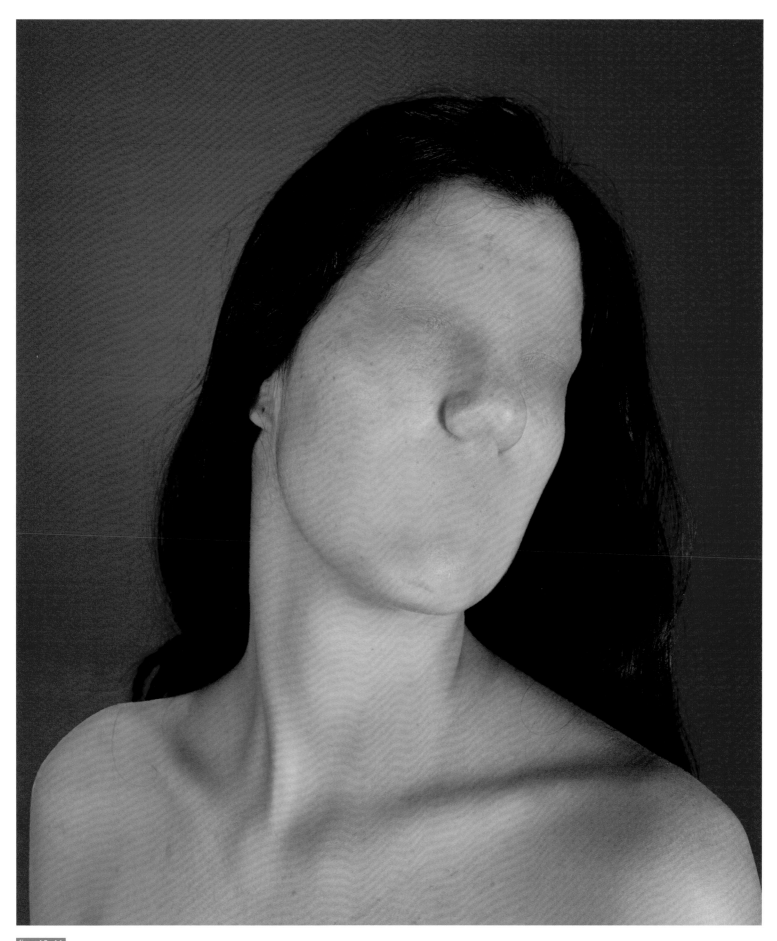

figs. 10–11

Maria and *Mike* from the *Dystopia* series, 1994–95
C-prints, each 50 x 40 in.

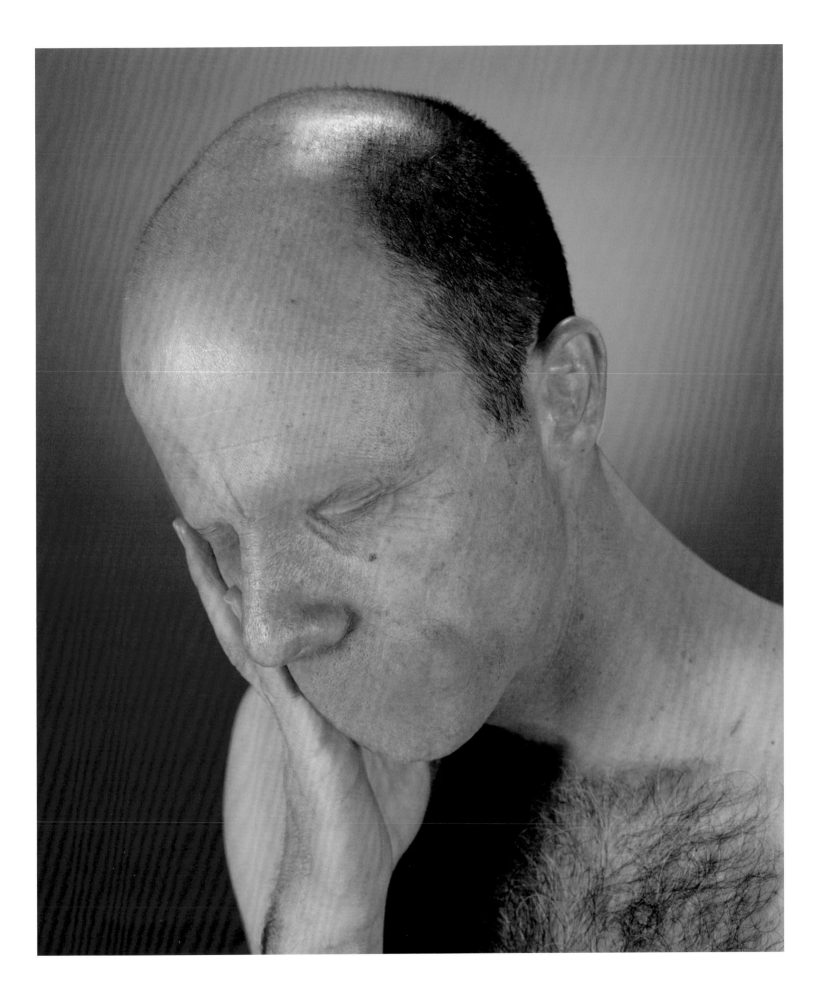

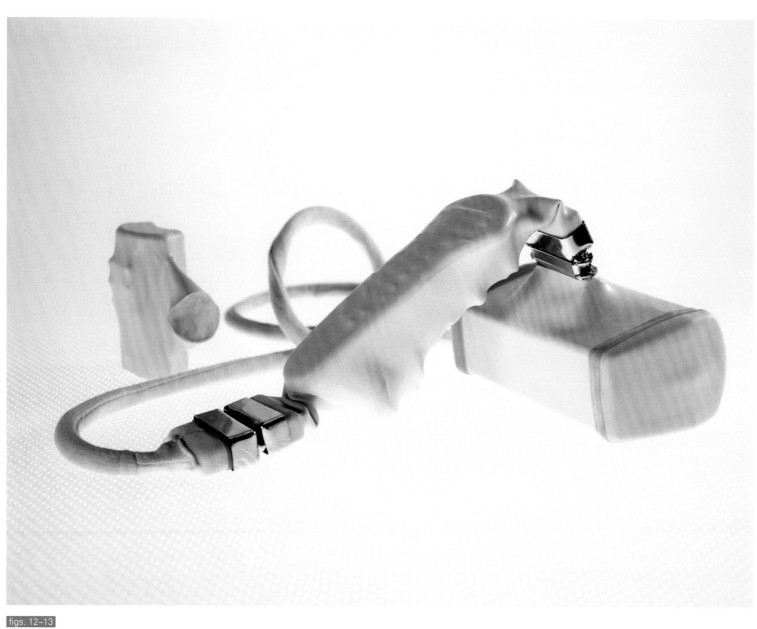

Plasmorphica, 1996
C-prints, each 30 x 40 in.

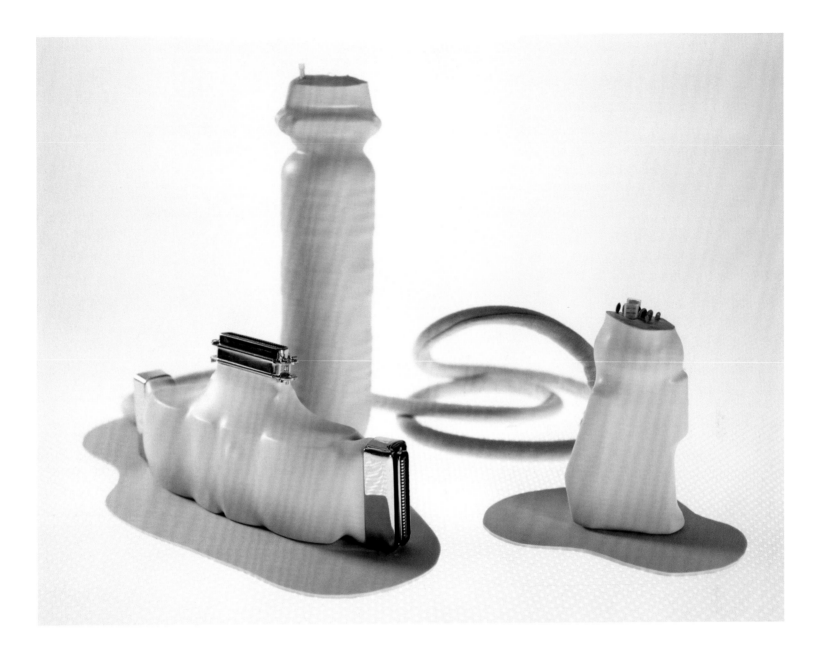

They stuffed them into Flesh Tube, a material used to make prosthetic devices, and then shrunk them to shape using a heat gun. The resulting odd photographs resembled stock photography of otherworldly products, strange biomorphic-electronic hybrids with no origins figs. 12–13. Later, they rearranged the "body parts" into unexpected compositions, poles that linked together different forms to create an immersive environment of *not*-body parts, forcing viewers to think of an unspeakable, but imaginable future fig. 14. In *Chimera* (1998), Aziz + Cucher re-photographed the objects from *Plasmorphica,* digitally manipulating the "skin" so that it seemed unnervingly natural figs. 15–18. Referencing the monstrous multi-part chimeras of ancient Greek mythology, the objects were further re-cycled with skin covered in recognizable freckles, blotches, and moles. They photographed the unique skins of different people and manipulated the images on the computer so they could cover the multi-part objects with an even more convincing looking membrane. Aziz + Cucher viewed these images "as 'specimens' in the same way that objects in natural history museums are photographed."[15]

According to the artists, the original intention of their next project, *Interiors* (1999–2000), was to explore the disappearing limits of the body because of the increasing influence of smart technology figs. 19–22. The photographs in this series are perhaps the most unhomely of all of Aziz + Cucher's projects to date because they represent uninhabitable architectural spaces, both actual and imagined, that have been digitally altered so that skin textures now overtake all of the interior building surfaces. Art critic Cay Sophie Rabinowitz acknowledges the inherent sense of the uncanny in one review of the work:

Discrepancy and reversal is built into the work—and exchange of information. The image presents an entirely uncanny solution: living skin transposed onto architecture; the human grafted onto the inhuman. The compositional strategy in Aziz + Cucher's work involves making an image stand for a state of mind. The equation is based on substitution, whereby the artificial interior situation is modeled after an organic interiorized state.[16]

Furthering the psychoanalytic reading of the work in his essay, "The Technology We Deserve," art historian Frazer Ward suggests that these photographs "are metaphors for the abandon and the terror of the collapse of distinctions between human and non-human, the attraction and the repulsion of the dissolution of limits. That is, as much as they are bound to the digital, they are also bound to a preexisting—and longstanding (think Frankenstein)—set of cultural anxieties."[17] The horrifically

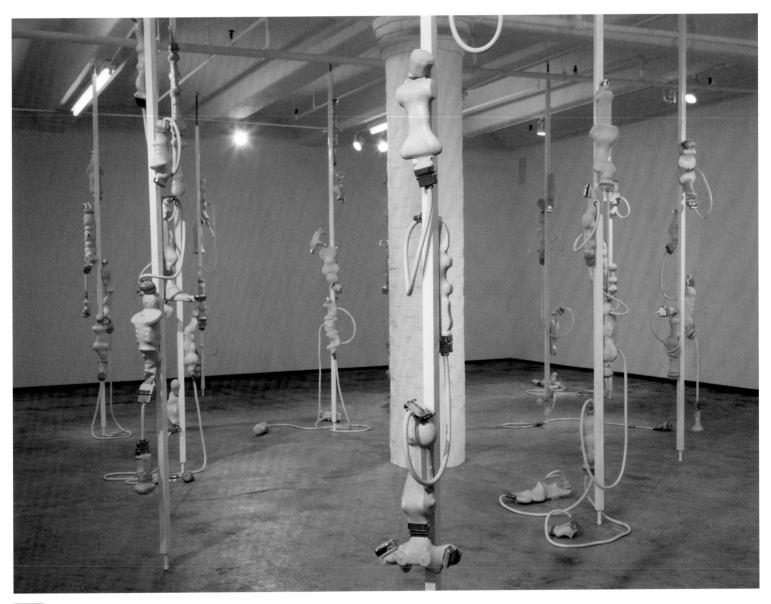

fig. 14

Plasmorphica, 1997
Sculptures installed at Jack Shainman Gallery, New York

Following pages:

figs. 15–18

Chimeras # 2, 5, 1, and *3* from the *Chimera* series, 1998
C-prints, each 60 x 30 in.

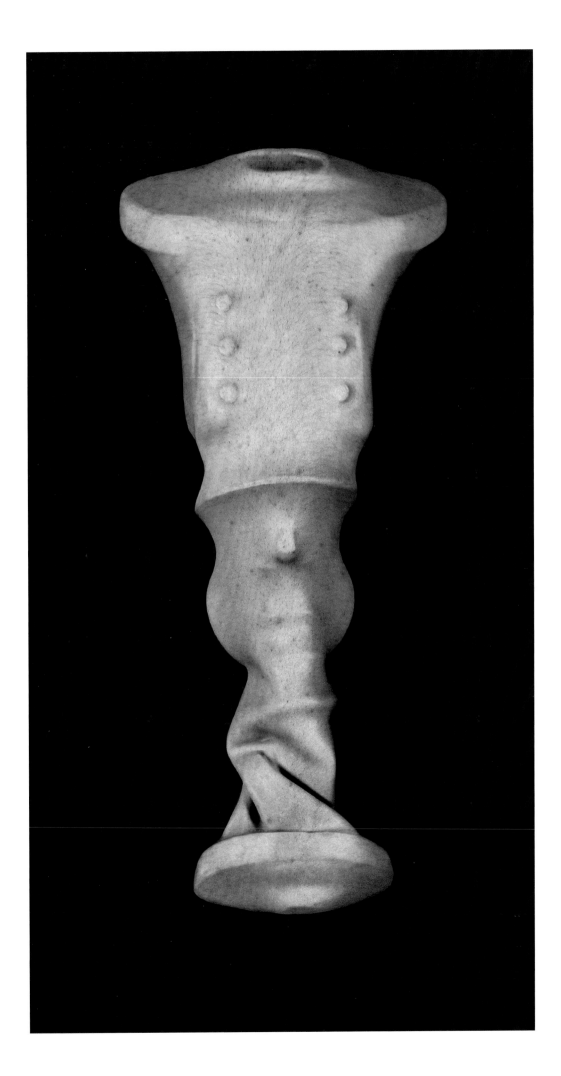

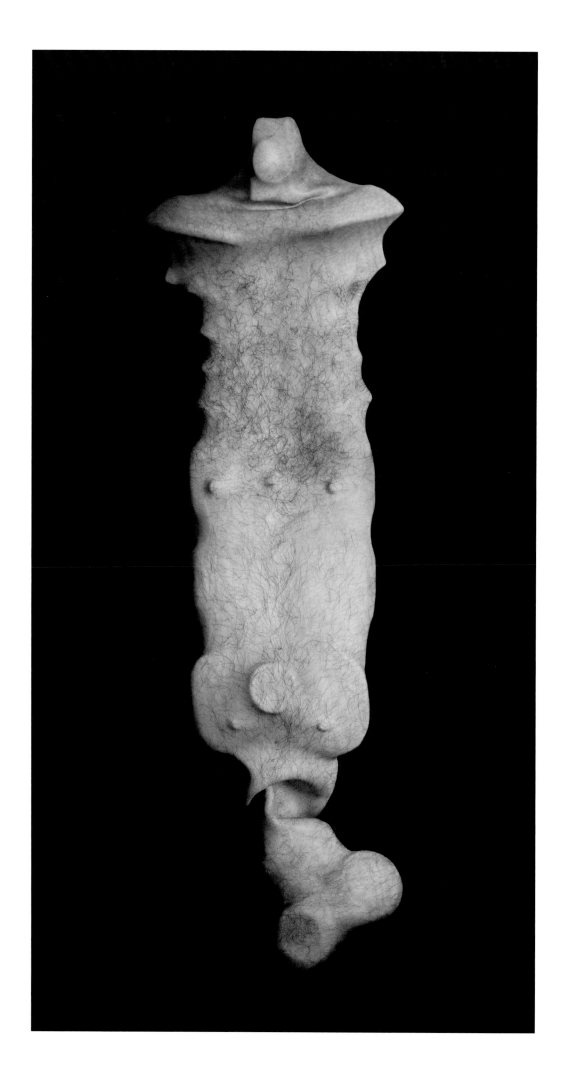

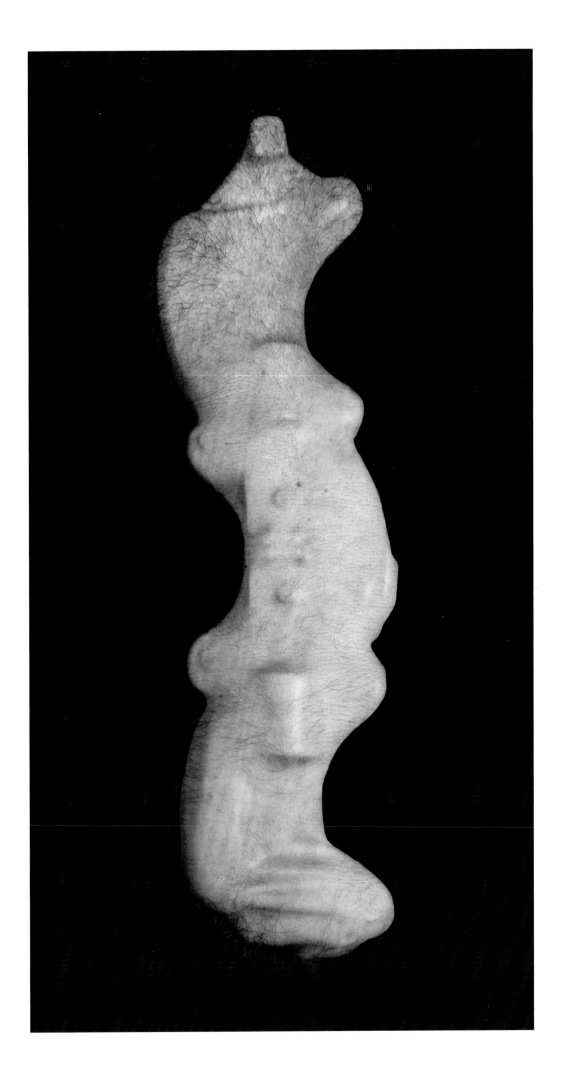

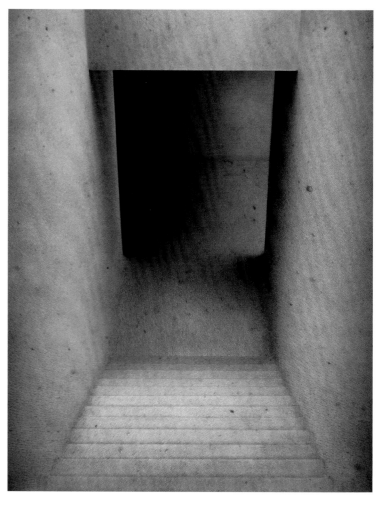

figs. 19–21

Interiors # 1, 2, and *6* from the *Interiors* series, 2000
C-prints, dimensions variable

Following pages:

fig. 22

Interior # 5 from the *Interiors* series, 2000
C-print, 50 x 72 in.

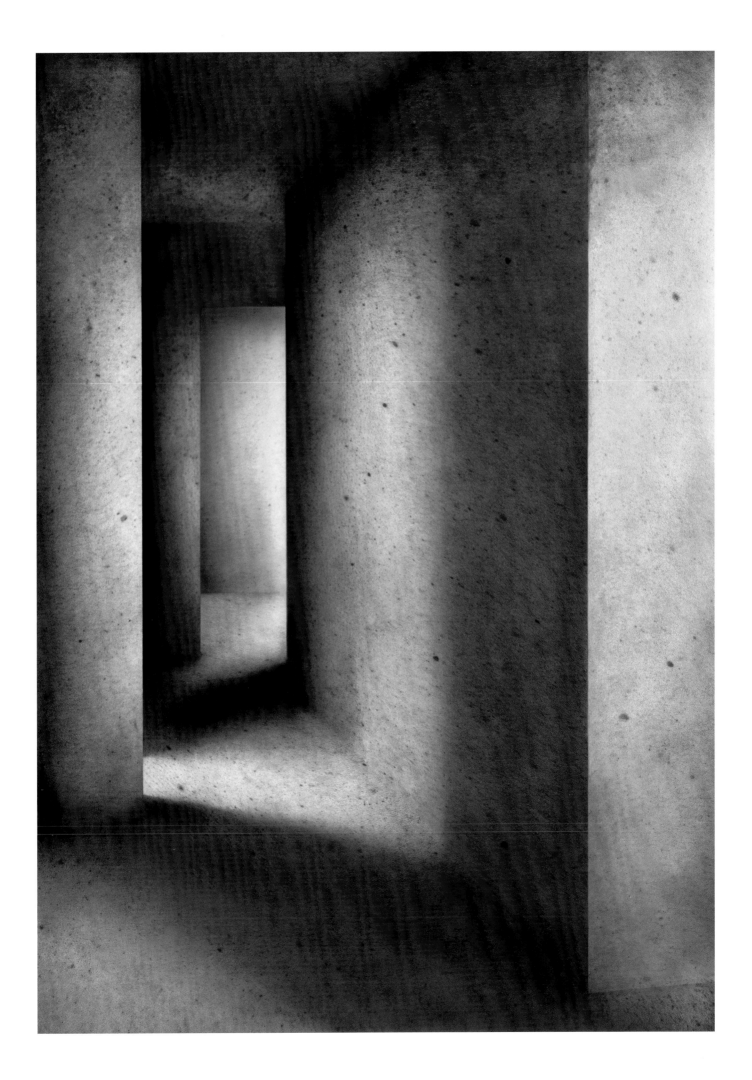

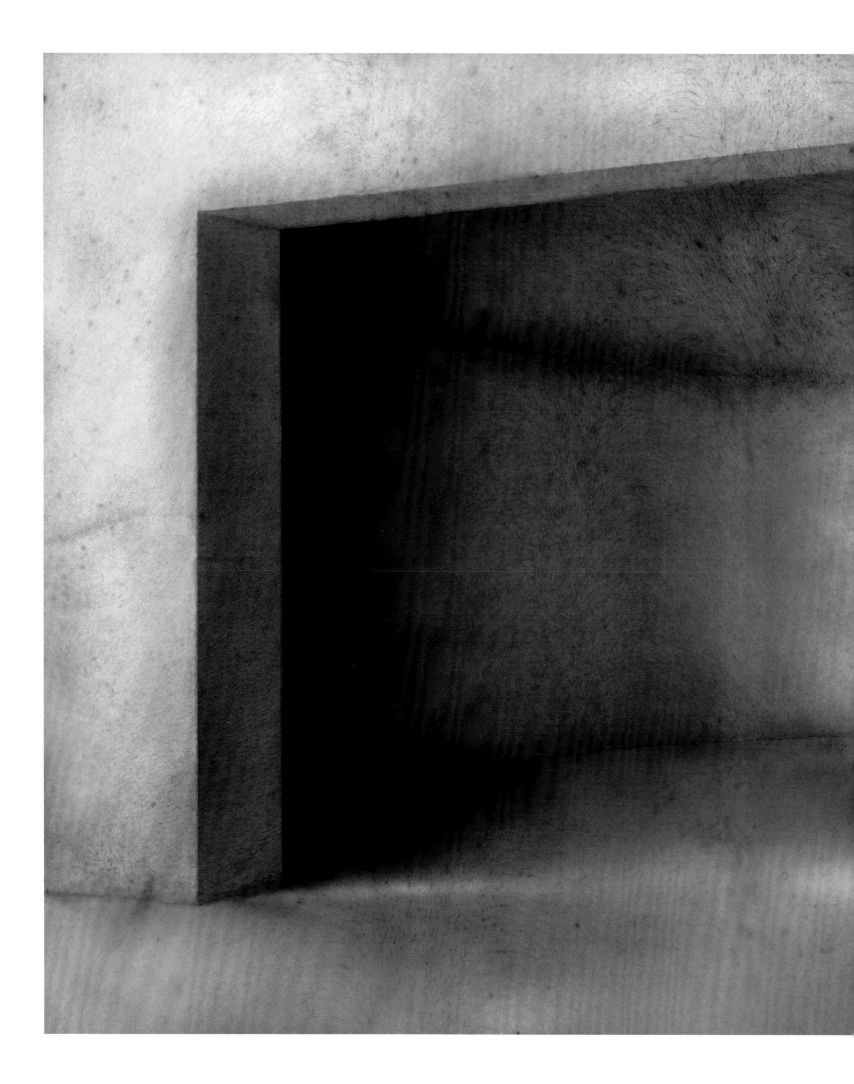

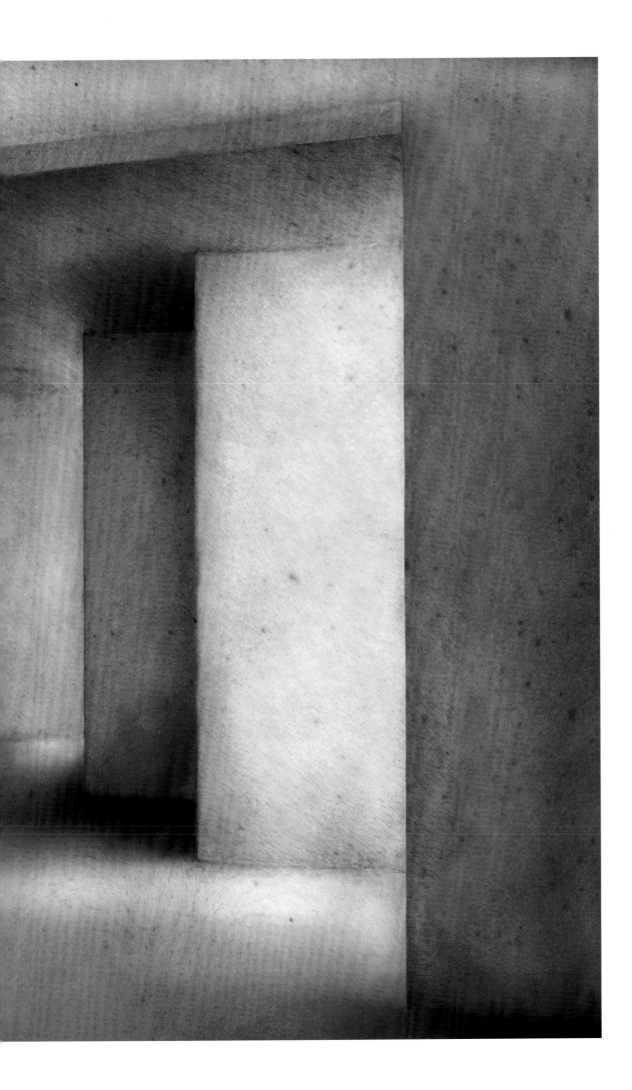

fascinating works in *Interiors* call into question the potential technological dissolution of the body considered throughout Aziz + Cucher's work.

In their next project, *Synaptic Bliss* (2003–06), Aziz + Cucher further eliminated the bounding condition of skin, focusing instead on what they refer to as "the life force," the physical and spiritual energy that runs through each of us figs. 23–26. *Synaptic Bliss* is perhaps Aziz + Cucher's most overtly personal and also most lyrical work; Cucher had been extremely sick with a serious illness and survived. He felt a sense of amazement in the mystery of the body's resilience: "there is something so powerful that keeps you alive that you have to investigate it . . . and give expression to it."[18] Aziz + Cucher began to imagine how it would look if this force could be liberated from the body and fused with the environment. They began experimenting with health and beauty aids that

bubbled and oozed, like shampoo, shaving cream, hair gel, Alka-Seltzer, and Pepto-Bismol, in order to produce a "kind of artificial nature."[19] They also photographed and filmed live footage of people in the landscape in Parc de la Villette in Paris, and combined all of the footage into a colorful, impressionistic video installation that intentionally blurs the boundaries between the inside and outside. Cucher explained: "If the body disappears—if you want to create a narrative out of this—the body becomes integrated into the landscape—it completely disappears—what's left is this consciousness that's observing and seeing and thinking, and how does that consciousness become a kind of technological consciousness?"[20] Reviewing the work, critic Jeffrey Walkowiak observed, "The images imply a material breakdown of the world around us in a hallucinatory fashion that recalls psychedelic states of mind that enhance a certain philosophical

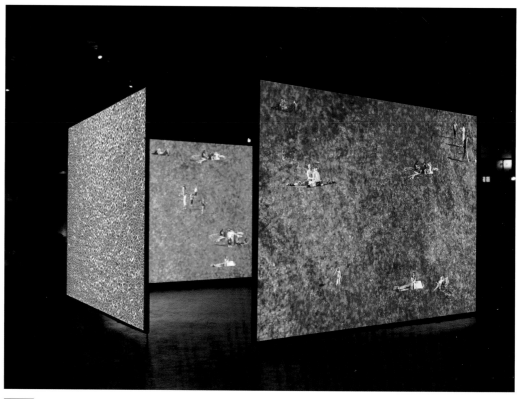

fig. 23

Synaptic Bliss_Villette, 2004
As installed at the festival Villette Numérique,
Parc de la Villette, Paris
Four-channel SD video with surround sound,
18 mins.

Opposite:
fig. 24
Ficus # 2 from the *Scenapse* series, 2007
Light-jet Endura Metallic print with Diasec
mount, 72 x 50 in.

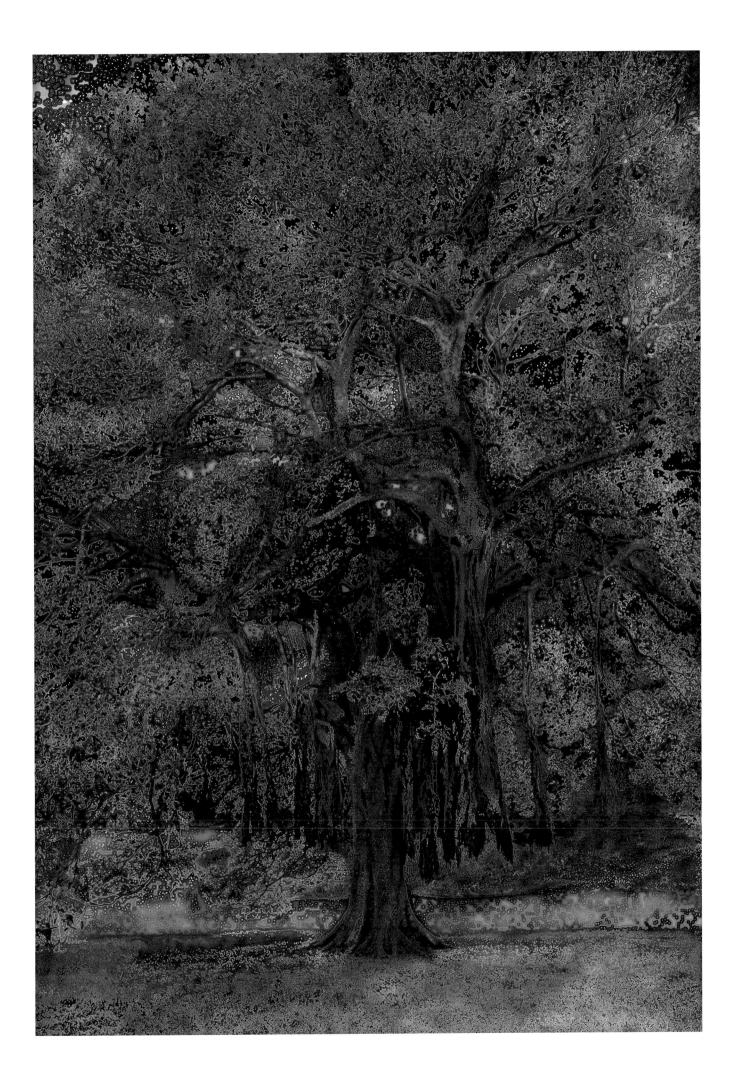

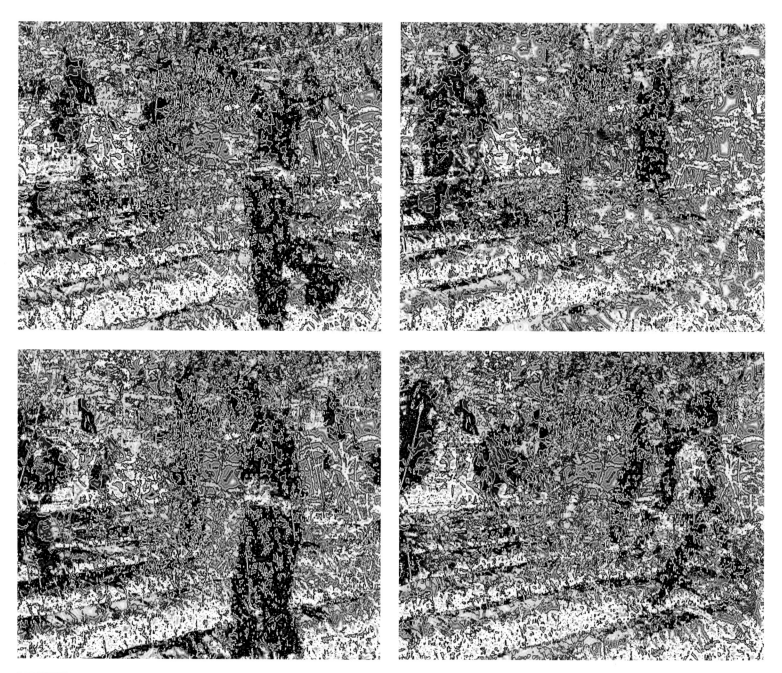

figs. 25–26
Synaptic Bliss_Villette, 2004
Video stills

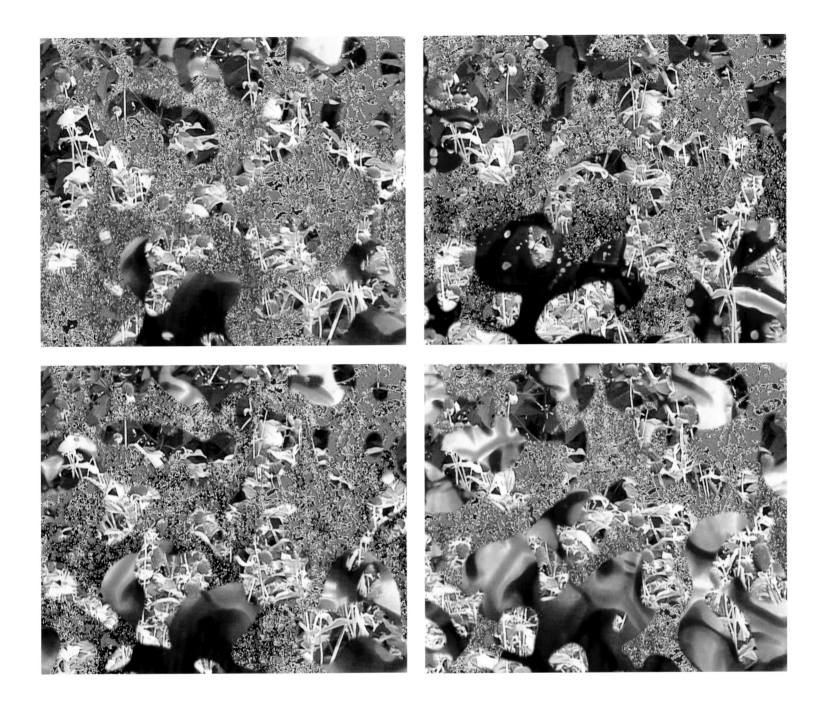

clarity. *Synaptic Bliss* represents the artists' shift in focus from the body to the landscape while capturing the body evaporating into the outer limits of the universe."[21]

Aziz + Cucher's intensely focused exploration of the uncanny space of the body and consciousness finds its logical culmination in *Some People*, a project that moves toward a more generalized investigation of the spatial uncanny in relation to an actual politicized landscape of conflict. The combination of 9/11, the 2006 war between Israel, Hezbollah, and Lebanon, and the War in Iraq pushed Aziz + Cucher to grapple with something that was the polar opposite of *Synaptic Bliss*' life force. How could they understand and elaborate on their combined sense of existential dread, depression, and hopelessness felt in response to never-ending human conflict? In 2009, Aziz + Cucher acknowledged that they needed to develop a new body of work that took seriously their

respective familial and aesthetic roots. Both artists were wary of the immensity of this task. How exactly could anyone represent the centuries of contested land ownership, extreme nationalist and religious ideologies, and historical prejudices that abound throughout the Middle East? One example came to them indirectly through an encounter with a poem in a bookstore. Cucher picked up a copy of the Polish Nobel Laureate Wisława Szymborska's collected poems after having read and enjoyed a number of her works published in *The New Yorker*. Inside the book, he discovered a poem called "Some People" and he was so moved by its "poetic distillation" of war, that he showed it to Aziz, suggesting that it might point to a future direction in their practice. Cucher explained: "Our resulting video installation *Some People* takes the conflict in the Middle East as a point of departure, but at the same time . . . [it speaks] . . . to a more

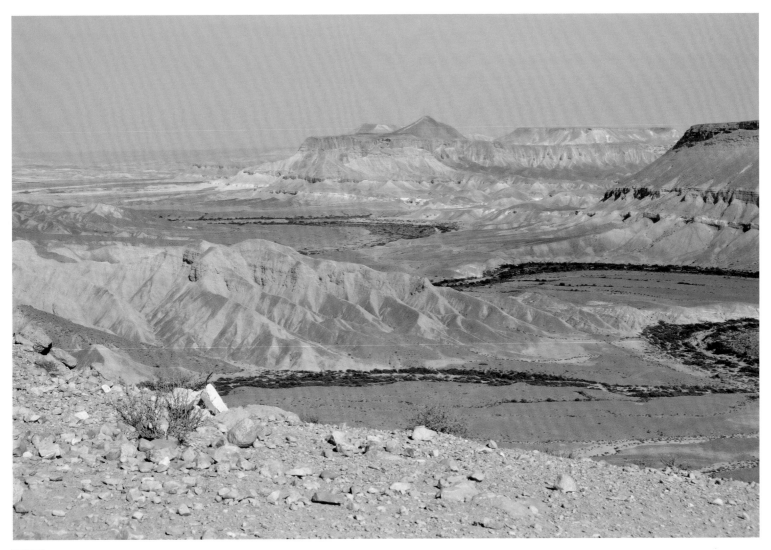

fig. 27

Residency, 2009
Image of the Negev Desert, Israel
Photographic journal

general human condition. It's about a general state of mind that produces conflict, a 'stuck-ness' into a certain belief or belonging to a specific group."[22]

With Szymborska's poem in hand and generous funding by the C-Collection, a private foundation based in Liechtenstein, Aziz + Cucher eventually set off on a six-month sabbatical from teaching at Parsons The New School for Design. They traveled extensively throughout Israel, Lebanon, and the Balkans, where they took countless photographs and video footage of the landscape, architectural ruins, an archaeological dig, daily life, and museum displays of historic cultural relics, some of which they published in their travel blog and book, *Residency* (2009).[23] One double-page spread at the beginning of the book depicts the vast, seemingly serene landscape of the Negev desert fig. 27 that belies the paradoxical history of violent conflicts that have transpired there throughout

the centuries. It subtly suggests the artifice of geographical boundaries that are invisible, yet politically charged. Aziz + Cucher's previous investigation into the shifting, fluid notions of the limits of the human body have here been brought to bear on the landscape itself, where lines of demarcation are socially constructed, contested, and continually redrawn in the endless struggles for ownership. Two photomontages included in the book—one a compilation of photographs of various mythological battles painted throughout history and shot at the Kunsthistorisches Museum in Vienna fig. 28, and the other a collage of photographs of television footage of war seen throughout their travels fig. 29 —point to the omnipresence of conflict represented throughout art history and popular media in contemporary life.

In Haifa, Israel, in June 2009, the artists worked with Manal Mahamid, a Palestinian-Israeli artist, to arrange to

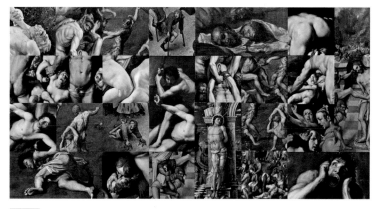

fig. 28
Collage of photographs taken at the Kunsthistorisches Museum, Vienna

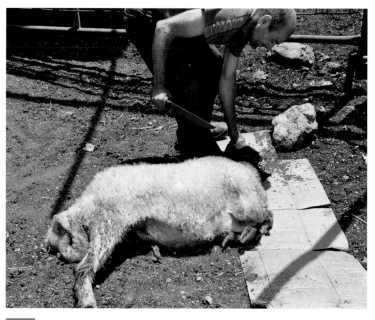

fig. 30
Yarka, Israel, June 2009

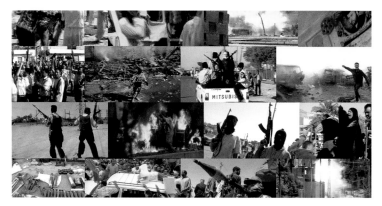

fig. 29
Collage of images of conflict lifted from news broadcasts

film the slaughter of a real lamb fig. 30. The biblical story of the sacrifice of Isaac has been represented throughout art history in fourteenth-century illustrated manuscripts and noted seventeenth-century paintings by Rembrandt and Caravaggio. But in Aziz + Cucher's graphic video, there is little interpretation in the footage other than the choice of framing and the proximity of the camera to the slaughter. At that time, the artists did not know how the film would play into their new work, but it clearly affected them, and they wrote about the experience in their blog, discussing their profound difficulty witnessing the death up close. Typically, when one refers to a sacrificial lamb, one is referencing a person or animal that is sacrificed for the common good; a scapegoat, or a victim. The fact that this was the only prearranged documentary shoot during the artist's residency points to the importance of the film in relation to the artists' residency and their developing ideas about the new body of work. It seems to have functioned as a kind of symbolic offering by the artists, a way of acknowledging their own distance from the Arab-Israeli conflict and their need to bear witness to it directly.

In Berlin during the final months of their residency, the artists worked in a rented studio with a green screen, collaborating with dancers, actors, and choreographers in order to begin developing a gestural choreographed language that could convey their various experiences, their complicated familial histories, and the eternal condition of struggle and renewal that characterizes humanity. Writing in their travel blog on September 15, 2009, the artists explained:

> Surprisingly, our work is becoming personal. For years, we have steered away from using ourselves and our own voices directly . . . but after being so deeply

affected by the many moving stories we heard and the people we met while traveling, we realize that this can no longer be the case. Something has shifted dramatically in the way we perceive our own practice and what we need to accomplish as artists at this particular moment. This attempt at putting ourselves in the work, to be as honest as we can about what we are attempting to do, began this week in a very literal way by us taking turns interviewing each other for the camera. Somewhat awkwardly at first, we managed to draw stories and emotions and reflections out of each other that we hope can act as a framework or a kind of script for the narrative structure we ultimately want to develop into a multi-channel media landscape.[24]

In Berlin, Aziz + Cucher continued their exploration of the Arab-Israeli conflict. For the first time in their relationship, they interviewed each other, sitting vulnerably between a green screen and camera. Uncostumed in this minimal environment, they initiated an unexpected interpersonal interrogation and discussed their thoughts about their own identities and familial histories fig. 31. This was a pivotal moment in their development of the new work as it allowed them to enter into the work directly, although not always literally.

Aziz + Cucher had both read Marguerite Yourcenar's fictional autobiography *Memoirs of Hadrian* (1951) and many of the ideas in this text resonated for them. In the chapter titled "Patienta," the old emperor is facing death and reflects on power, destruction, and renewal throughout history:

Catastrophe and ruin will come; disorder will triumph, but order will too, from time to time. Peace will again establish itself between two periods of war; the words *humanity, liberty,* and *justice* will here and there

regain the meaning which we have tried to give them. Not all our books will perish, nor our statues, if broken, lie unrepaired; other domes and other pediments will arise from our domes and pediments . . . [25]

The first installation in *Some People,* entitled *Time of the Empress,* functions as a prologue to the exhibition. It consists of three 72 x 127 inch freestanding double-sided screens suspended from the ceiling, creating an immersive minimalist environment reminiscent of the large screens in *Synaptic Bliss.* But here, there is no color or joyful impressionism, just stark black and white. The large vertical screens contain austere digitally animated architectural drawings that are in a constant paradoxical cycle of growth and disintegration fig. 32 . In total, there are twenty international-style skyscrapers projected against white backdrops that are depicted in different sequences across the screens so that they always vary

and are never empty. The buildings, according to the artists, "refer to modernist architecture, as a way to subsume even the present and the recent past in the flow of History." They are comprised of repeated units that can be aggregated, and were designed in relation to various façades that were vaguely inspired by iconic modernist architects such as Mies Van der Rohe, Pier Luigi Nervi, Norman Foster, and Archigram. Aziz + Cucher spent many hours choreographing the motion, "deciding on things like the speed of the decay, the weight of the downward motion, the timing of the build up and collapse."[26]

As an American viewer, these tall, detailed projections evoke the Twin Towers and the endlessly recycled media footage of the 9/11 terrorist attacks in New York. Although the artists insist this association was unintentional, they have recognized its inescapability:

fig. 31
Video stills from interviews the artists conducted of each other in Berlin, 2009

Following pages:
fig. 32
Time of the Empress, 2012
Video stills
Three-channel HD video loop, stereo sound, 10:33 mins.

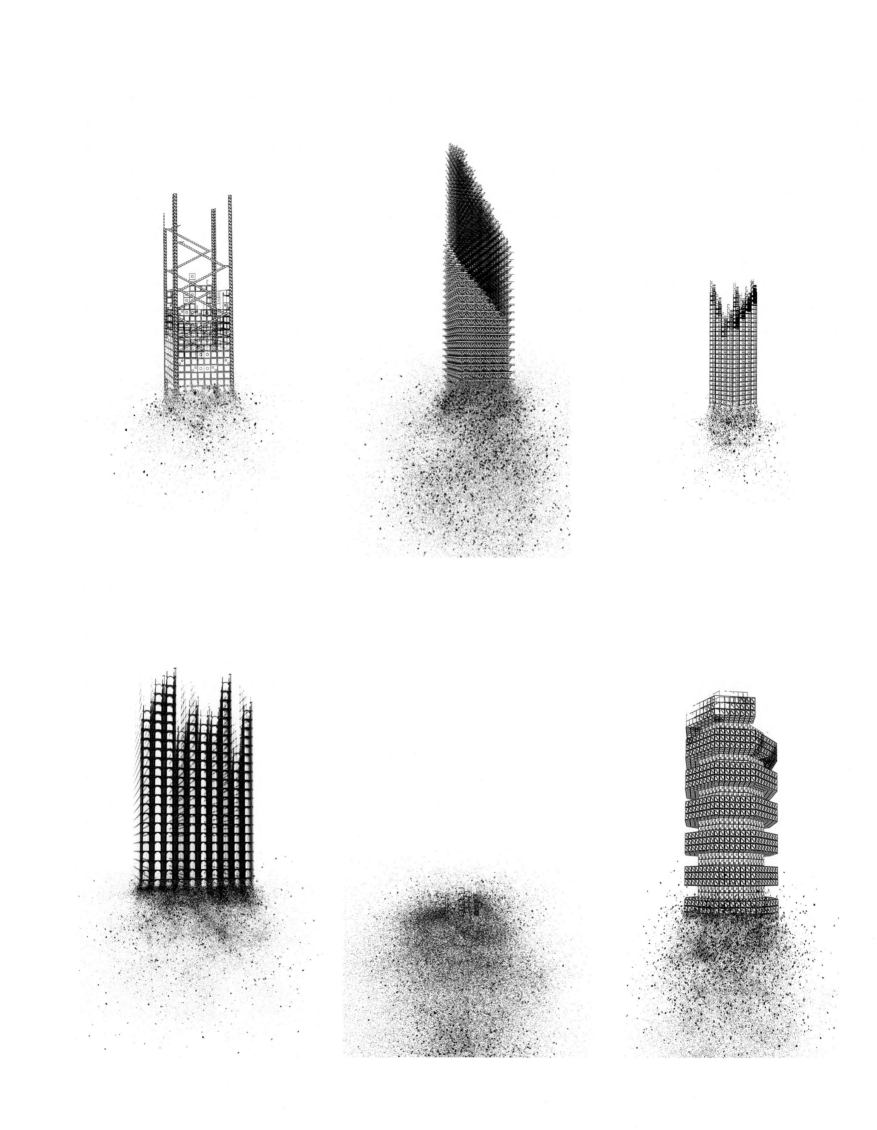

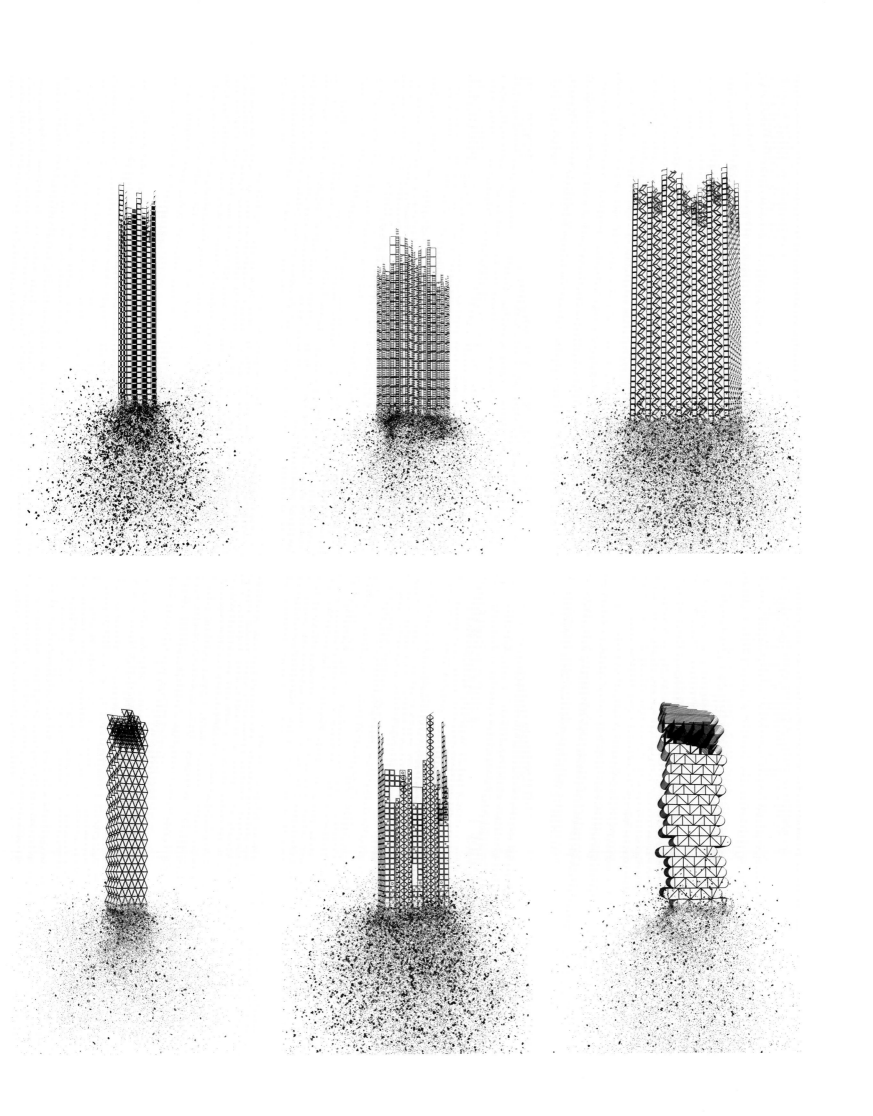

We could not avoid it and [needed] to [acknowledge] that we live in this world after this event . . . We don't present it explicitly, but we make you want to think about it; at the same time we don't want to make you think about it in a completely negative way, but it's kind of more the historical perspective in which things disappear, they are destroyed, and they grow again.[27]

Certainly their residency helped reinforce this understanding of the ongoing cycles of decay and renewal, not just in the United States, but throughout the Middle East and Balkans, as well as the consequent anxiety and unsettledness that comes with living in the midst of traumatic ruins while going about daily life. During their residency, Aziz + Cucher photographed countless bombed-out and bullet-ridden buildings, and they began to understand the experience of modern life in these cities as having a "normality effect," which essentially allows people to maintain a veneer of calm denial alongside an awareness that at any moment a bomb might drop.

In Mostar [a divided town with an invisible demarcation line between the Croatian Catholic side and the Bosnian Muslim side], there are physical reminders of brutality everywhere, so the juxtaposition of a normal life with the memories of the war attain a particularly surreal level. One building, for example, is completely pockmarked and half destroyed by shells, yet two of its floors have been renovated and are inhabited, while the middle floor remains, a wreck . . .[28] fig. 33

Here we can see another example of the spatial uncanny, a continuation of the landscape marked by invisible boundaries, a synthesis of the past and the present, two seemingly impossible realities absurdly juxtaposed side by side. Brian Jarvis similarly has identified this

fig. 34
Mostar, Bosnia and Herzegovina, July 2009

fig. 33
Mostar, Bosnia and Herzegovina, July 2009

catastrophic condition in the post-9/11 city where people experience an unexpected feeling of déjà vu because the attacks have been represented endlessly in the media and in our memories.[29] In many ways, the two collaged compilations of paintings and media representations of conflict gathered during their residency can be seen as a condensation of traumatic déjà vu. This recycling of aesthetic and media depictions of trauma, the nature of remembering and forgetting, is temporarily repressed, for example, when Aziz + Cucher witness a crowd of young hipsters partying on a posh rooftop terrace in Mostar and rocking out to the music of a live band from Belgrade, another city plagued by crisis fig. 34.

After experiencing the silence of *Time of the Empress,* the viewer enters an adjacent gallery that features *In Some Country Under a Sun and Some Clouds,* an eight-channel video and sound installation that gets its title from the second and third lines of Szymborska's poem. Aziz + Cucher's installation is both an example of Vidler's "transcendental homelessness" and a respectful homage to Szymborska's influential poetic vision; it alludes to the legacy of war, trauma, and instability, conjuring the related conditions of uprootedness, forced nomadism, and homelessness through mise-en-scène, costume, gesture, movement, and sound. The video depicts eight individuals struggling to move against the backdrop of a vast desert landscape of biblical proportions. Projected onto three walls encompassing the viewer, the trans-historical figures wear earth-toned clothes styled by Beto Guedes in a "tribal-post-apocalyptic pastiche" that represents no specific culture, gender, place, or time fig. 35. The artists started working on this project in Berlin, collaborating with the Israeli dancer and choreographer Maya Lipsker. In the workshop, they emphasized specific

Following pages:
fig. 35
In Some Country Under a Sun and Some Clouds, 2012
Video stills
Four-channel HD video projection, surround sound, 13:06 mins.

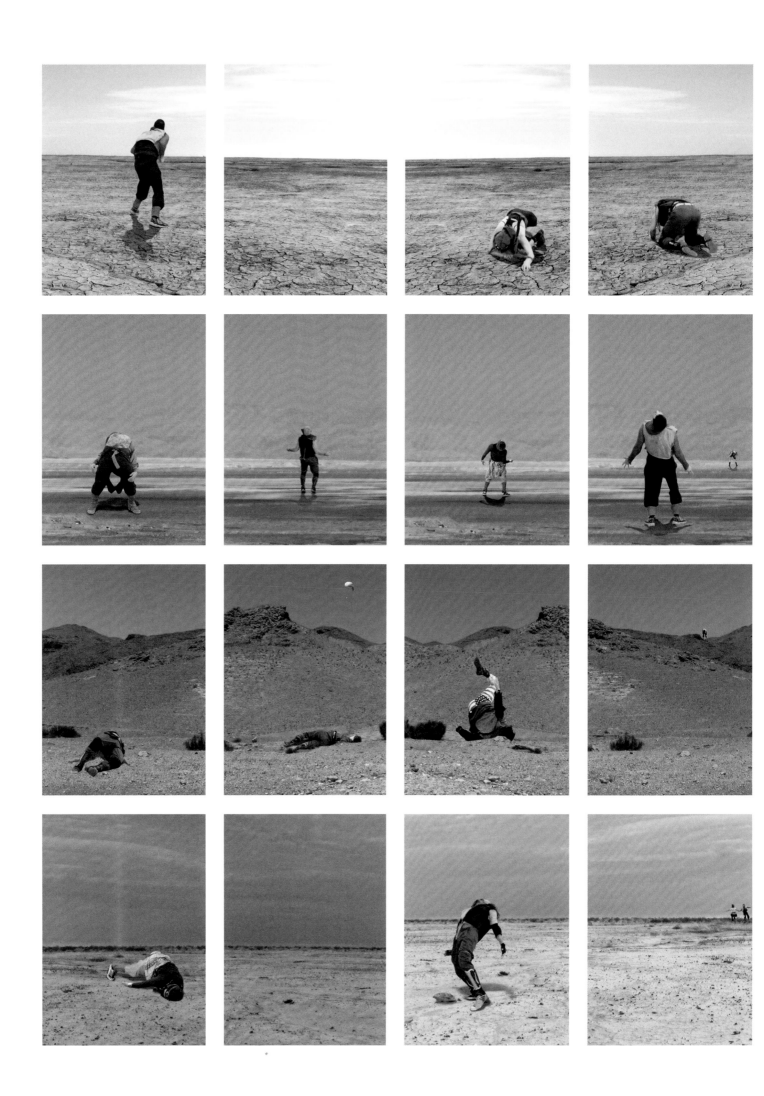

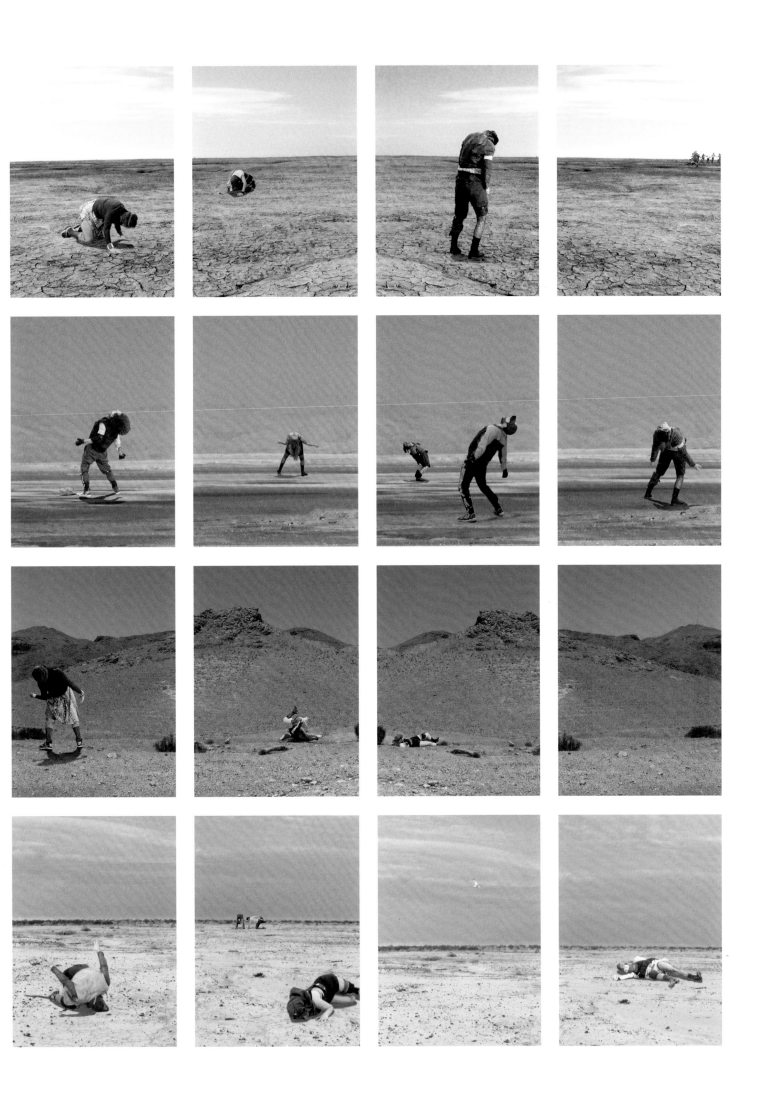

tasks, such as "exploring gestures around gravity and the pull of the earth, being stuck and struggling to move, attraction and repulsion, fighting an invisible enemy."[30] Afterward, they isolated a few gestures and invited some of the dancers to a green-screen shoot where they continued to improvise fig. 36. The video footage from this shoot became the basis for digital manipulation: "isolating very small units and looping them, testing the tension between the natural movement and the mechanical repetition, seeing how the movements could become tragic or comical depending on the timing."[31] Eventually Aziz + Cucher realized they needed to restage the dancers in a bigger studio that could accommodate group folk dances, and this footage appeared in the final video. In June 2011, Lipsker visited Aziz + Cucher in New York and together they recruited nine performers who participated in a two-day workshop along with the dancer Pedro Osorio.

They studied the Berlin shoots and developed a choreographed phrase that could be taught to the dancers in subsequent rehearsals. The result was a collection of ten gestures that each dancer could perform and interpret over approximately twelve minutes. After the New York workshops, Aziz + Cucher began "re-choreographing each sequence, pairing them in the landscapes, and then composing further groupings."[32]

The resulting writhing, jerking, desperate-seeming bodies seen in the video installation seem to be caught in an eternal state of paralysis and indecision. This condition is amplified by the fact that each of the twelve-minute video projections forms a repetitive loop that reiterates the tension between the simultaneous desire and inability to escape their current predicament. The figures are at once tragic and absurd, but they also veer on the pathetic and whimsical, generating an overall disquieting sense

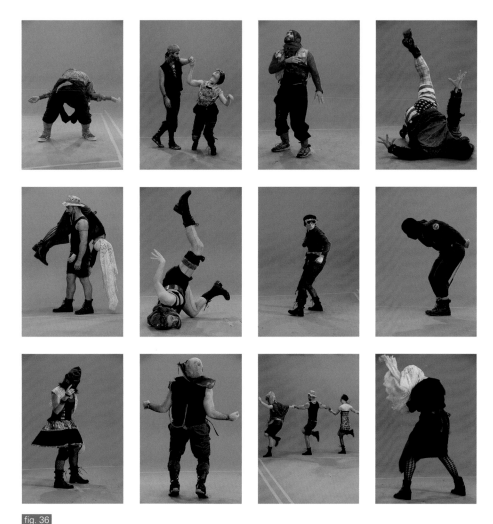

fig. 36
Dancers during a green-screen
shoot in New York, 2011

for the viewer. Like the costumes and choreography, the soundtrack has also been created through unexpected combinations, creating an atmospheric collage of voices and sounds from different places and times—epic Balkan singers, Jewish folk music, Serbian wedding music, and field recordings. These tracks are interspersed with a low-frequency pulse that becomes an intense unifying motif for the entire landscape.

Moving into the next gallery, a visitor shifts from what is clearly a wholly manufactured and fictional landscape to what seems at first to be an ordinary active archaeological site in Israel. *A Report from the Front* is a five-minute single-channel video filmed during Aziz + Cucher's residency that documents American Christian college students who are digging for evidence of the life of Jesus in a Roman-Jewish town in northern Israel, near its borders with Lebanon and Syria fig. 37. In this

work, Aziz's early fascination with documentary film and political propaganda returns in what becomes a parody of the documentary genre itself. Cucher's forceful authoritarian-sounding voice-over issues a fallacious and nonsensical "report" on an unspecified "front" or former battlefield, using quasi-scientific, militaristic language and threatening rhetoric: "RDM and eco-sonograph probes have been commanded to prove that the ashes remaining on the floor testify to fire that destroyed the city gate and is ascribed to the Assyrian King Tiglath-Pileser III."[33] The script intentionally comments on historic land ownership and the search for archaeological proof of such claims, but in a completely ridiculous manner. This false narrative becomes a representation of the contemporary archaeological uncanny, suggesting spatial and historical instabilities, perplexity, and the fine line between truth and fiction.

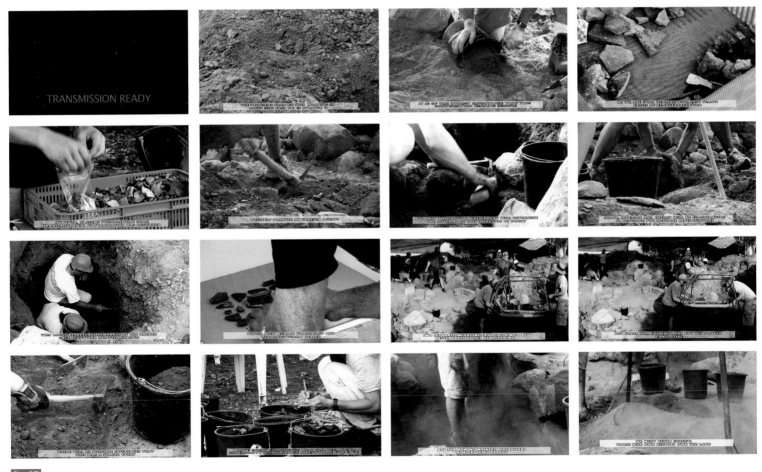

fig. 37

A Report from the Front, 2012
Video stills
Single-channel HD video, stereo
sound, 4:35 mins.

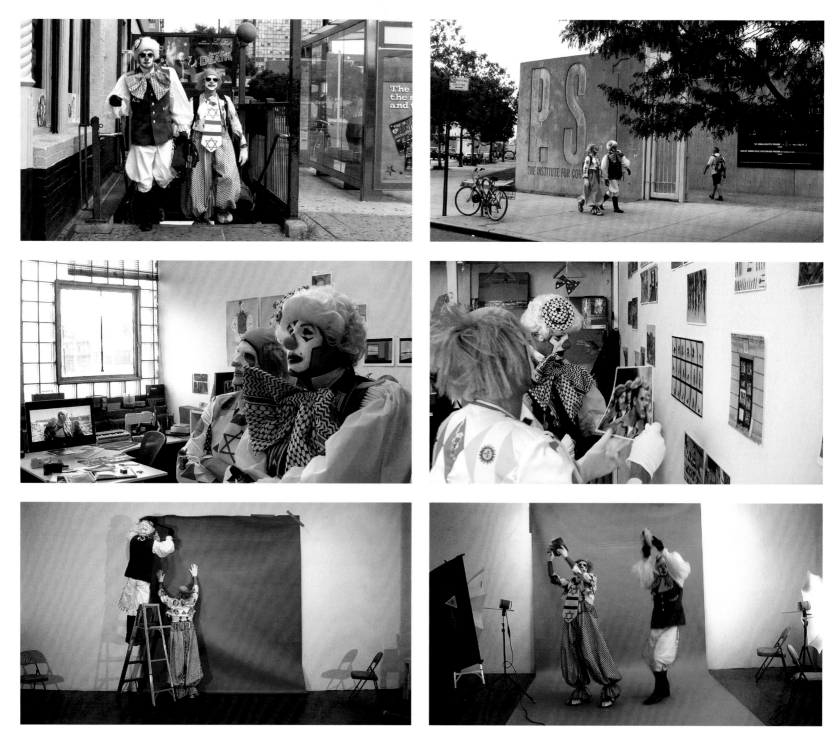
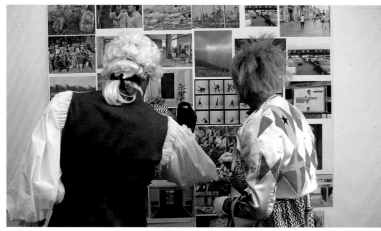
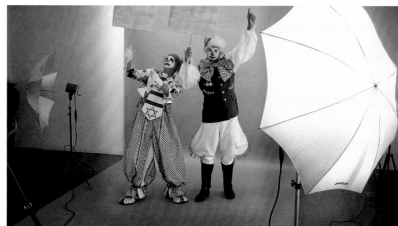

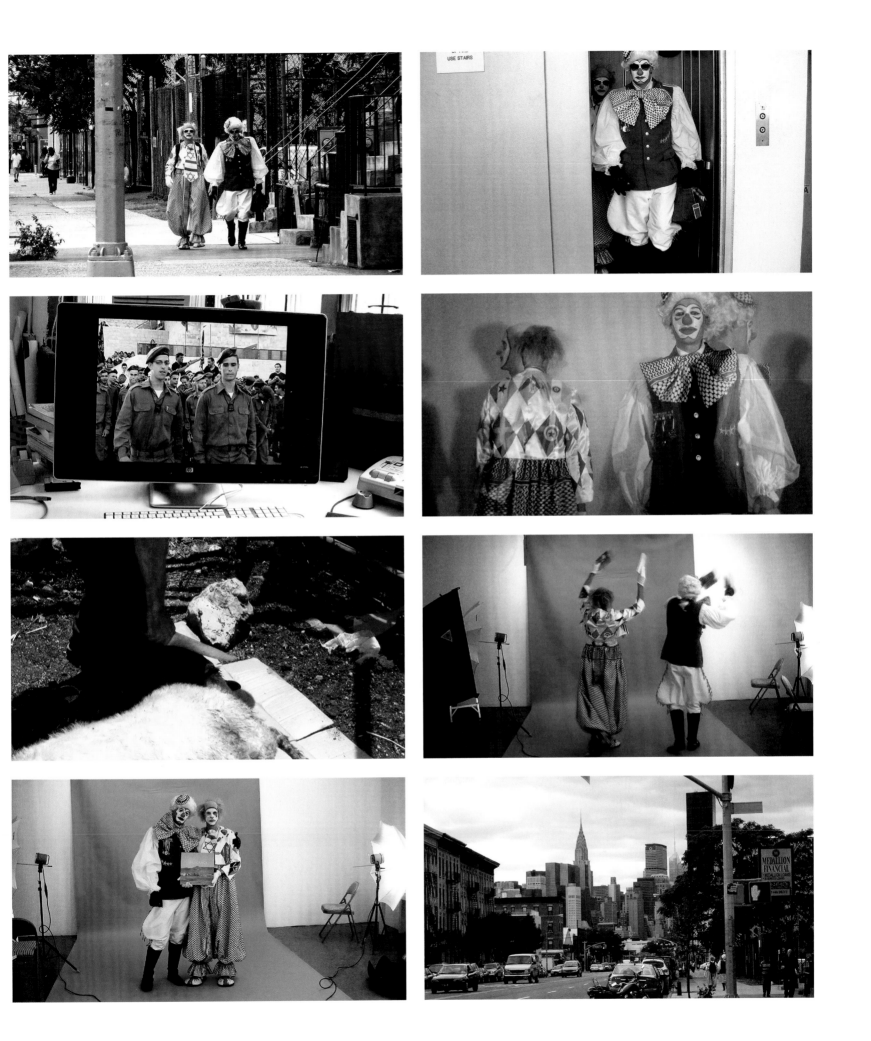

The final room of the exhibition features a large single-channel video projection and six flatscreens that can be viewed as the artists' first self-portrait in their twenty-year collaboration. *By Aporia, Pure and Simple* represents a day in the studio life of Aziz + Cucher fig. 38. The artists emerge from the 23 St-Ely Avenue subway stop in Long Island City, Queens dressed up not in their normal attire, but as two clowns: Aziz wears a militaristic costume with a giant floppy *keffiyeh* bowtie and Cucher appears ridiculously cosmopolitan, sporting an outfit comprised of different textiles from around the world, including a large tie with two Stars of David. Although they had the costumes designed by Yashi Tabassomi while they were still in Berlin, Aziz + Cucher were unsure of how they would incorporate them into their new work. While reviewing all of the material that they had generated once they were back in the States, they came up with the idea of the video. They explained: "We really felt . . . like clowns. Going around Israel and Palestine with our little video camera, and talking to people and recording voices."[34] The clowns became a vehicle through which they could self-critically insert themselves into this material: ". . . [T]he clown is always that character [who] tries to fix something that's broken and breaks it even more, he never gives up because he's so determined, but wrong. So we felt that was us."[35]

The nine-minute single-channel video begins with the familiar sounds of NPR's Morning Edition with Linda Wertheimer and Steve Inskeep, reporting on the conflict in the Middle East. We see Aziz + Cucher walking through the streets with the familiar skyline of New York behind them. They take the elevator up into their studio where we hear a barrage of media reports about the suspension of direct peace talks between the Arabs and Israelis. Throughout

Previous pages:
fig. 38
By Aporia, Pure and Simple, 2011
Video stills
Single-channel HD video projection,
six looped DVD displays, surround
sound, 8:43 mins.

the condensed day there is a dizzying stream of media reports in English, Hebrew, Farsi, and Arabic alongside TV news reports about the Middle East that appear on a monitor. Reinforcing this palimpsest of newscasts, Aziz + Cucher also layer other sounds to conjure "the confused mash-up in [their] heads," including Israeli folk music, Lebanese ancestral songs, recordings of the Koran and Hebrew Psalms, a flutist playing Israel's national anthem, *Hatikvah,* and a Dub track given to them by their Bosnian guide. To increase the sense of disorientation, they sometimes play the folk music backwards or speed it up so that it is unnaturally fast and bewildering. The radio, television, and sound components simulate the media bombardment and related desensitization that Americans experience daily regarding news about the Middle East.

As we watch the artists arrange and rearrange the photographic stills taken during the residency and edit their selections with black Sharpies fig. 39, the camera zooms in closely on various unrelated images including a roadside watermelon stand shot in Ramallah and a lost peacock waiting in the middle of a road in Tiberias. Throughout the video, the camera pans from photographs that fill the camera frame to more distanced shots showing the artists evaluating their documentary material. In this way, the video points to Aziz + Cucher's simultaneous immersion within the landscape of the Middle East while also underscoring the artists' physical distance from the crisis. In one section we see young Israeli army inductees who march out of sync during a ceremony taking place in front of the Western Wall. Each receives a gift of a rifle and the Bible. The camera zooms in on their uncoordinated footwork, eventually cutting to a segment where Aziz + Cucher humorously approximate the militaristic movements figs. 40–41. Their colorful clown costumes blur

fig. 39

By Aporia, Pure and Simple, 2011
Video stills
Single-channel HD video projection,
six looped DVD displays, surround
sound, 8:43 mins.

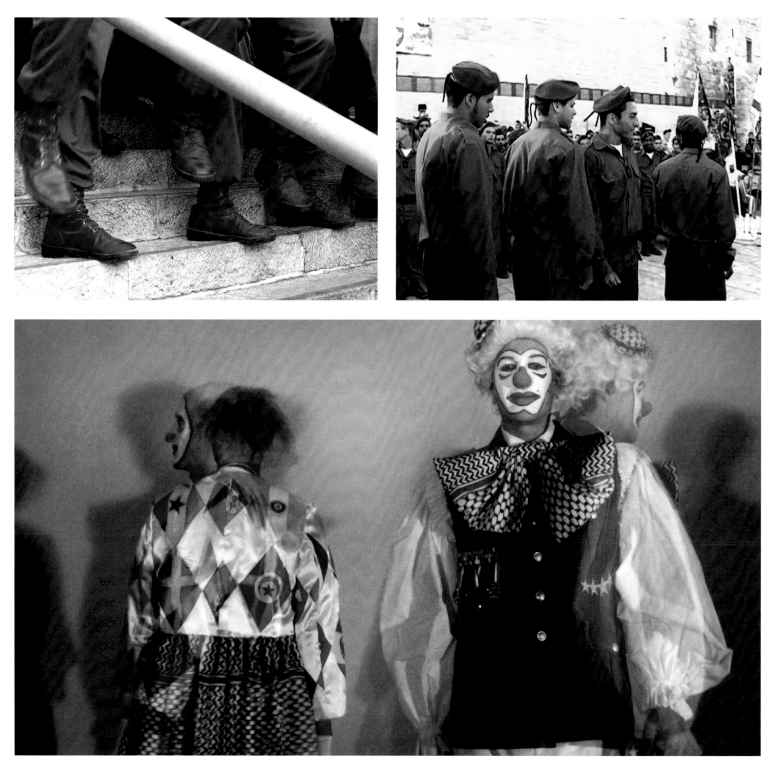

Top:

fig. 40

By Aporia, Pure and Simple, 2011
Video stills of inductees into the Israeli army,
filmed in Jerusalem in 2009
Single-channel HD video projection, six looped
DVD displays, surround sound, 8:43 mins.

Bottom:

fig. 41

By Aporia, Pure and Simple, 2011
Video still
Single-channel HD video projection, six looped
DVD displays, surround sound, 8:43 mins.

against the white walls of their studio as they march and spin frenetically, suggesting the overall disorientation induced by the cacophonous soundtrack and the bombardment of imagery from different cultures, locations, and temporalities. Throughout the video, we see glimpses of sketches that became portions of each of the works included in the exhibition—a building from *Time of the Empress,* developing stills from *In Some Country Under a Sun and Some Clouds,* documentary footage from *A Report from the Front.* The video is itself a palimpsest of their journey through this new body of work, an accumulation of observations, images, sounds, and experiences that metaphorically conjure the space of the transcendental uncanny.

At the conclusion of the video, in contrast to the hysterical, unstable sensorial barrage, Cucher stares quietly, looking out the studio window into the industrial landscape of Queens; Aziz collapses exhaustedly into a chair. They reunite to pose for their self-portrait in front of a group of cameras while holding a copy of their book, *Residency* fig. 42, and then they leave the studio, walking down the street toward the distant subway tracks and city. The mundane nature of their day is accentuated in six flatscreen monitors that depict long takes of people seen throughout their residency engaged in daily activities. These people walk down their streets, swim at the beach, and shop in markets, demonstrating an uncanny resilience and "normalcy" in the face of constant threats fig. 43. As Tami Katz-Freiman suggests in her essay, the title of this work *By Aporia, Pure and Simple* derives from *The Unnamable,* a novel by Samuel Beckett: "The narrator rhetorically asks himself: 'How do you go on living?' and answers: 'By Aporia, pure and simple.'" According to Katz-Freiman:

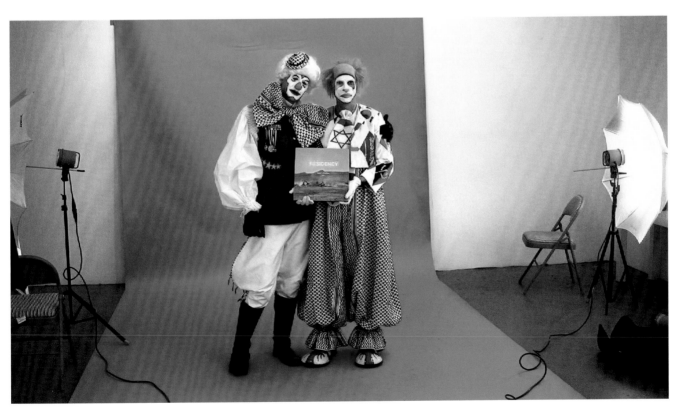

fig. 42

By Aporia, Pure and Simple, 2011
Video still of self-portrait of Aziz + Cucher with their photographic journal *Residency*
Single-channel HD video projection, six looped DVD displays, surround sound, 8:43 mins.

59

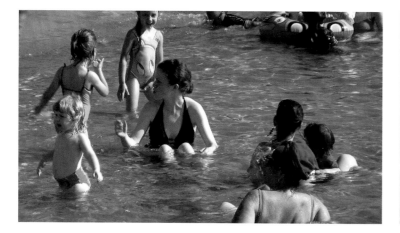

fig. 43

By Aporia, Pure and Simple, 2011
Video stills from footage of everyday life
captured during the artists' travels, as included
on flat-screen monitors in the installation
Single-channel HD video projection, six looped
DVD displays, surround sound, 8:43 mins.

"The word 'aporia' has a typically Beckettian meaning, referring as it does to an irresolvable internal contradiction or disjunction."[36] By *Aporia, Pure and Simple*, and by extension all of the work in *Some People*, acknowledges this precise existential conundrum, creating an aesthetic metaphor for the contemporary spatial uncanny comprised of ambiguity, odd juxtapositions of reality and fiction, the erasure of boundaries, and the effect of "transcendental homelessness." *Some People* forces us to ask, in the midst of such senselessness, What else can we do but repress the horror until it turns on us once again? Szymborska's poem closes with a stanza that recognizes this "old-established" uncanny and its inevitable, eventual return despite our desire to forget it:

Something else is yet to happen, only where and what?
Someone will head toward them, only when and who,
in how many shapes and with what intentions?
Given a choice,
maybe he will choose not to be the enemy
and leave them with some kind of life.[37]

1 "The Uncanny," in *The Standard Edition of the Complete Psychological Works of Sigmund Freud, Volume XVII (1917–1919): An Infantile Neurosis and Other Works*, trans. J. Stachey (London, 1955), p. 240.

2 As quoted by Richard Meyer in "'Very Bad Clowns': An Interview with Anthony Aziz and Sammy Cucher," in present catalogue, p. 107.

3 Robert Hughes, "Art: The Whitney Biennial: A Festival of Whining," *Time Magazine* (March 22, 1993).

4 Roberta Smith, "At the Whitney, a Biennial with a Social Conscience," *The New York Times*, March 5, 1993.

5 Andrew Russeth, "MoMA PS1 Curator Peter Eleey Discusses 9/11 Exhibition," *The New York Observer*, July 29, 2011.

6 Brian Jarvis, "New York, 9/11," in *Urban space and Cityscapes: Perspectives from Modern and Contemporary Culture*, ed. Christopher Linder (New York, 2006), p. 58.

7 Ibid., p. 57.

8 Ibid., p. 58.

9 Anthony Vidler, "Introduction," *The Architectural Uncanny: Essays in the Modern Unhomely* (Cambridge, Massachusetts, 1992), p. 7.

10 Ibid., pp. 7–8.

11 Ibid., p. 11.

12 Anthony Aziz as quoted by Jeffrey Kastner, "These are the Forms We Live with: A Conversation with Thyrza Nichols Goodeve," in *Nature*, Documents of Contemporary Art, ed. Jeffrey Kastner (London, 1999).

13 Ibid.

14 Vince Aletti, "Choices," *Village Voice*, June 6, 1995.

15 As quoted in e-mail exchange with the author, March 19, 2012.

16 Cay Sophie Rabinowitz, "Aziz + Cucher: Landscapes and Interiors," in *Aziz + Cucher*, exh. cat. Artereal Gallery (Sydney, 2006).

17 Frazer Ward, "The Technology We Deserve," *Parkett* 60 (2000 / 01), pp. 190–92.

18 Sammy Cucher as quoted in interview with the author, October 14, 2011.

19 Ibid.

20 Ibid.

21 Jeffrey Walkowiak, "When the Mind Sees More Than the Eye," *Scenapse: Nueva Fotografía* (Barcelona / Madrid, 2008).

22 Sammy Cucher as quoted in interview with the author.

23 A made-on-demand photographic journal.

24 Aziz + Cucher, "September 15, 2009" (blog), http://azizcucher.blogspot.de/2009/09/berlin-september-15th.html.

25 Marguerite Yourcenar, *Memoirs of Hadrian* (New York, 1974), p. 293.

26 As quoted in e-mail to the author, February 18, 2012

27 Sammy Cucher as quoted in interview with the author, October 14, 2011.

28 Aziz + Cucher, "Normality Effect" (blog), July 9, 2009, http://azizcucher.blogspot.de/2009/07/normality-effect.html.

29 Jarvis 2006 (see note 6), p. 56.

30 As quoted in e-mail to the author, February 29, 2012.

31 Ibid.

32 Ibid.

33 Aziz + Cucher, *A Report from the Front*, script of voiceover, 2012.

34 As quoted in interview with the author, October 14, 2011.

35 Ibid.

36 Tami Katz-Freiman, "From Body Politics to Conflict Politics: Aziz + Cucher Come Out of the (Biography) Closet," in present catalogue, p. 88.

37 Wisława Szymborska, "Some People," in *Miracle Fair*, trans. Joanna Trzeciak (New York, 2001), p. 56.

TIME OF THE
EMPRESS

IN SOME COUNTRY UNDER
A SUN AND SOME CLOUDS

A REPORT FROM
THE FRONT

BY APORIA, PURE
AND SIMPLE

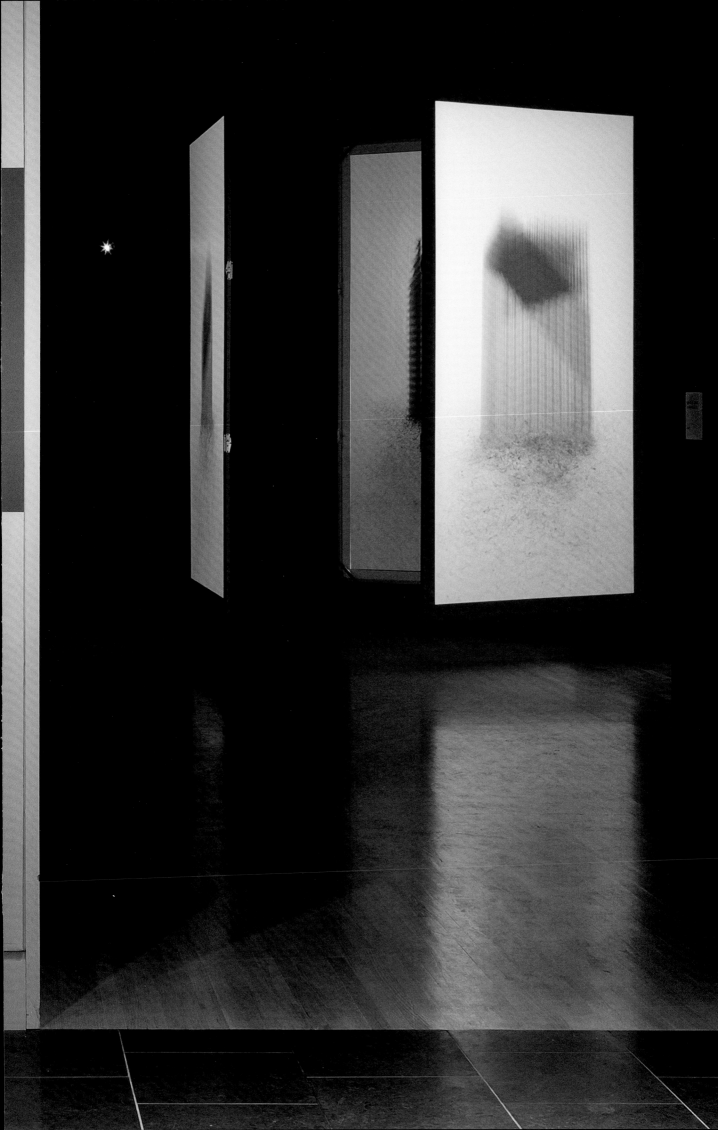

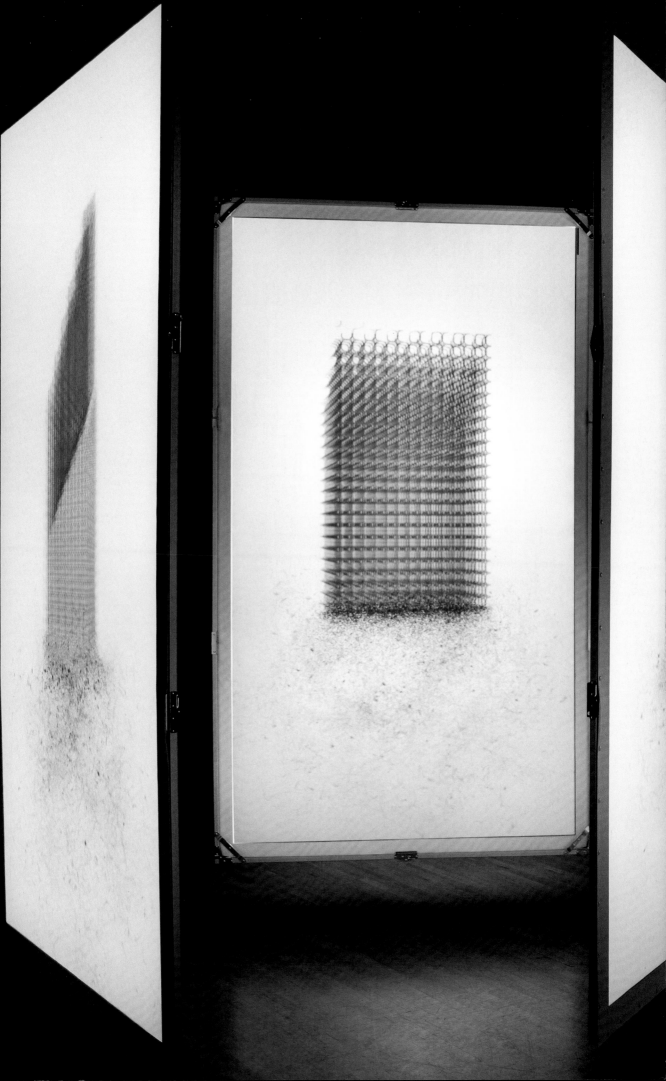

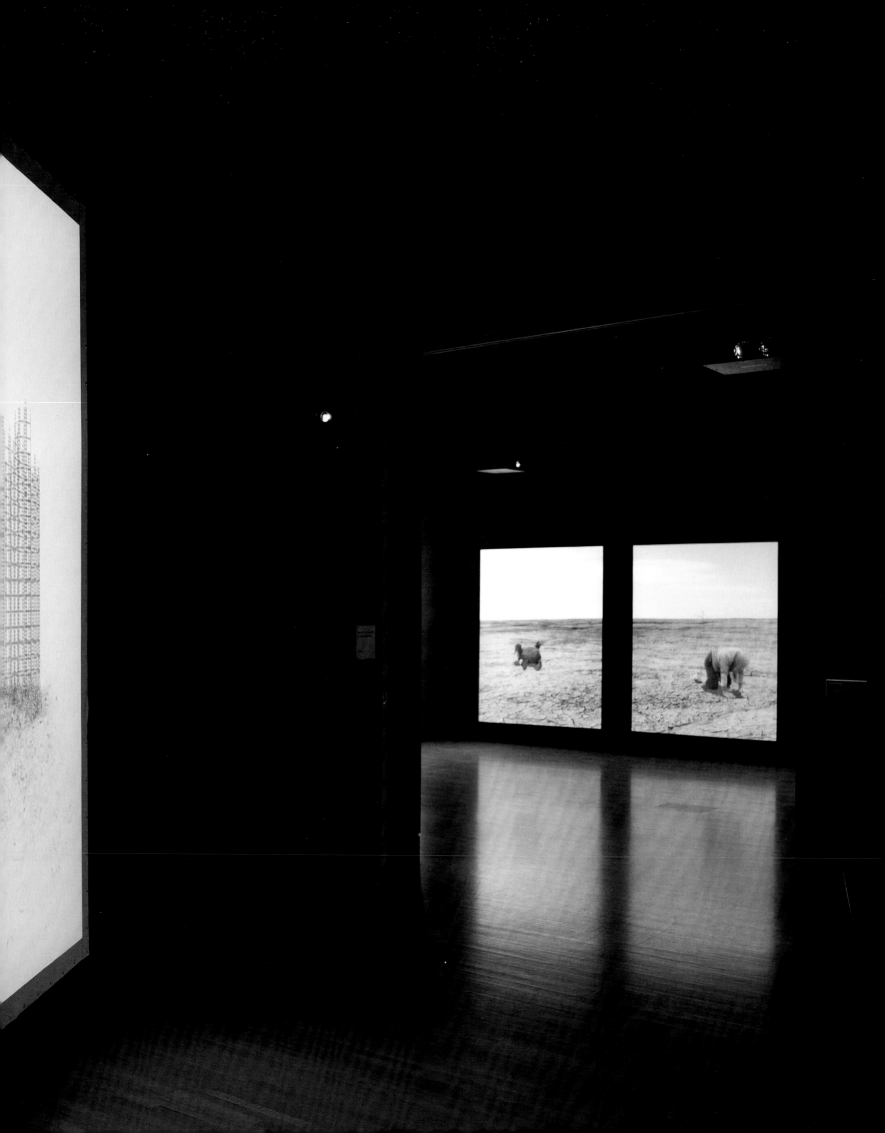

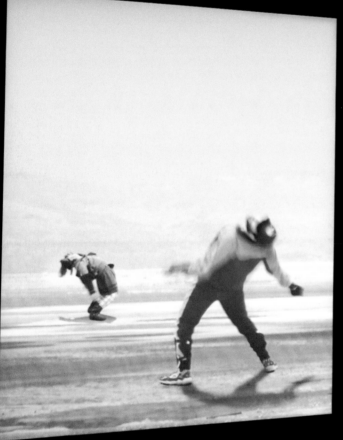
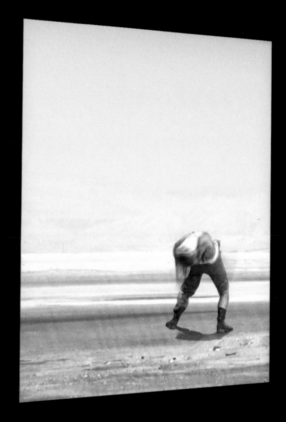

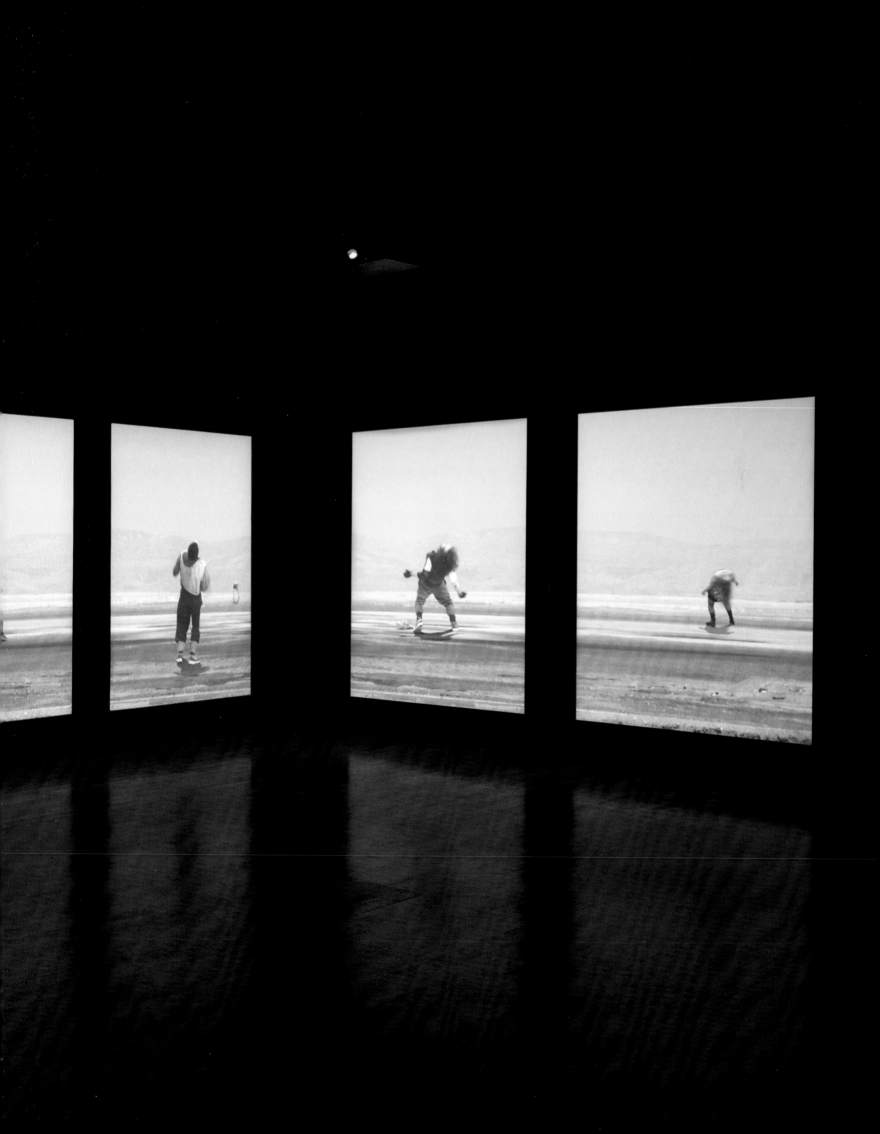

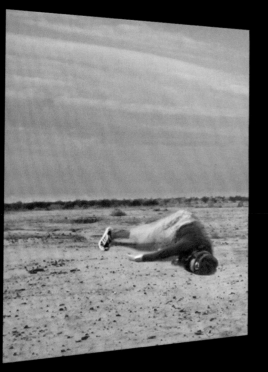
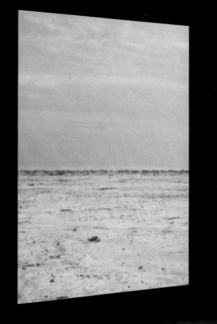
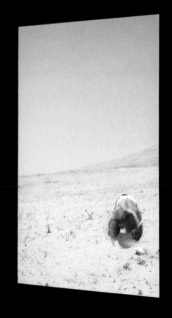

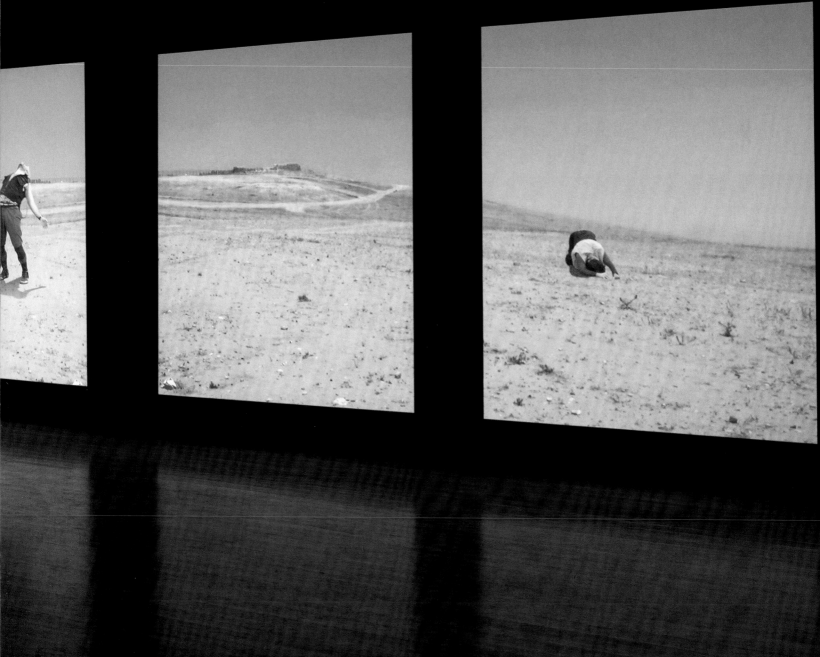

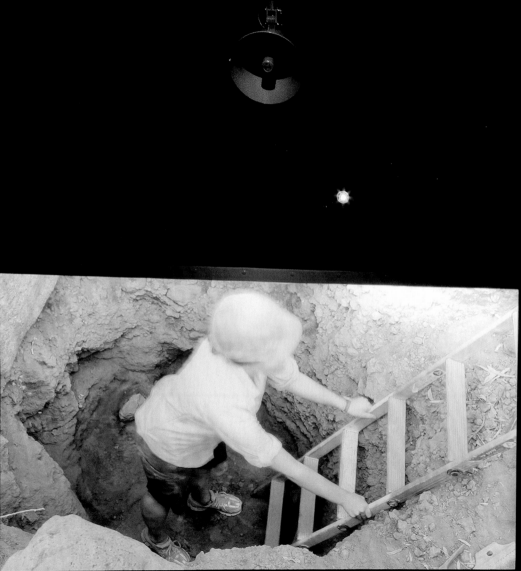

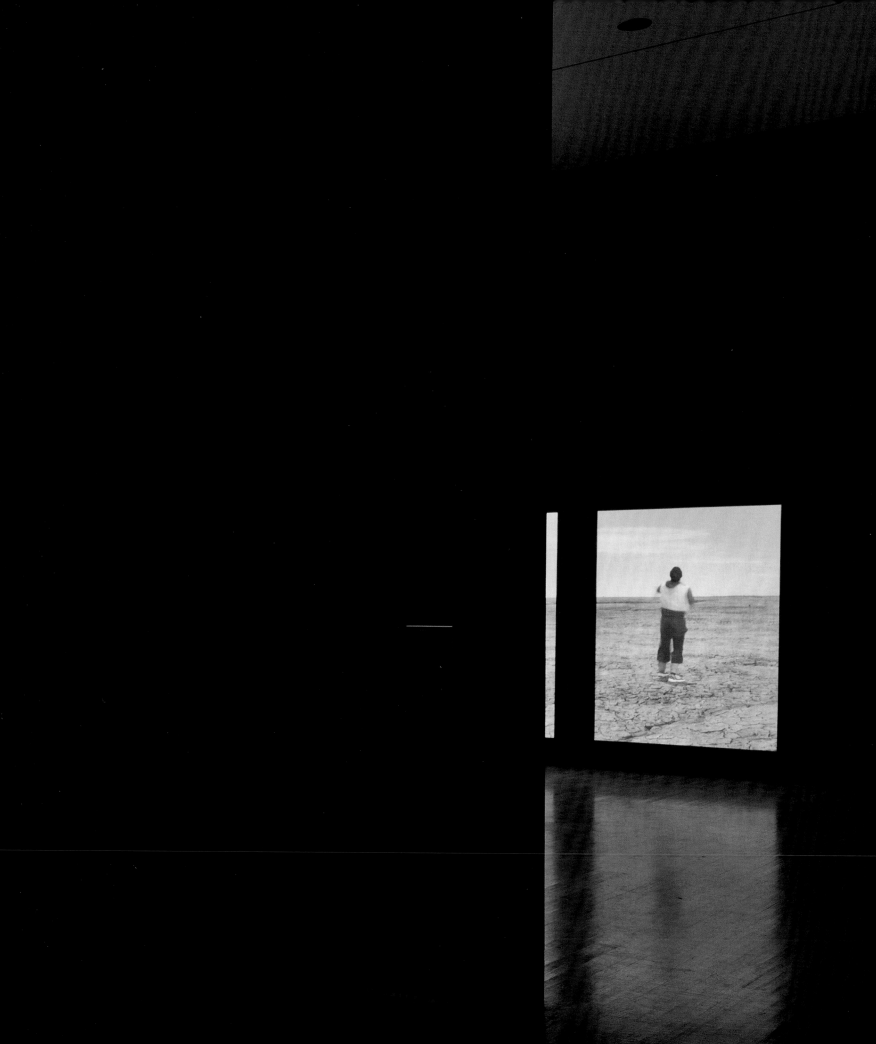

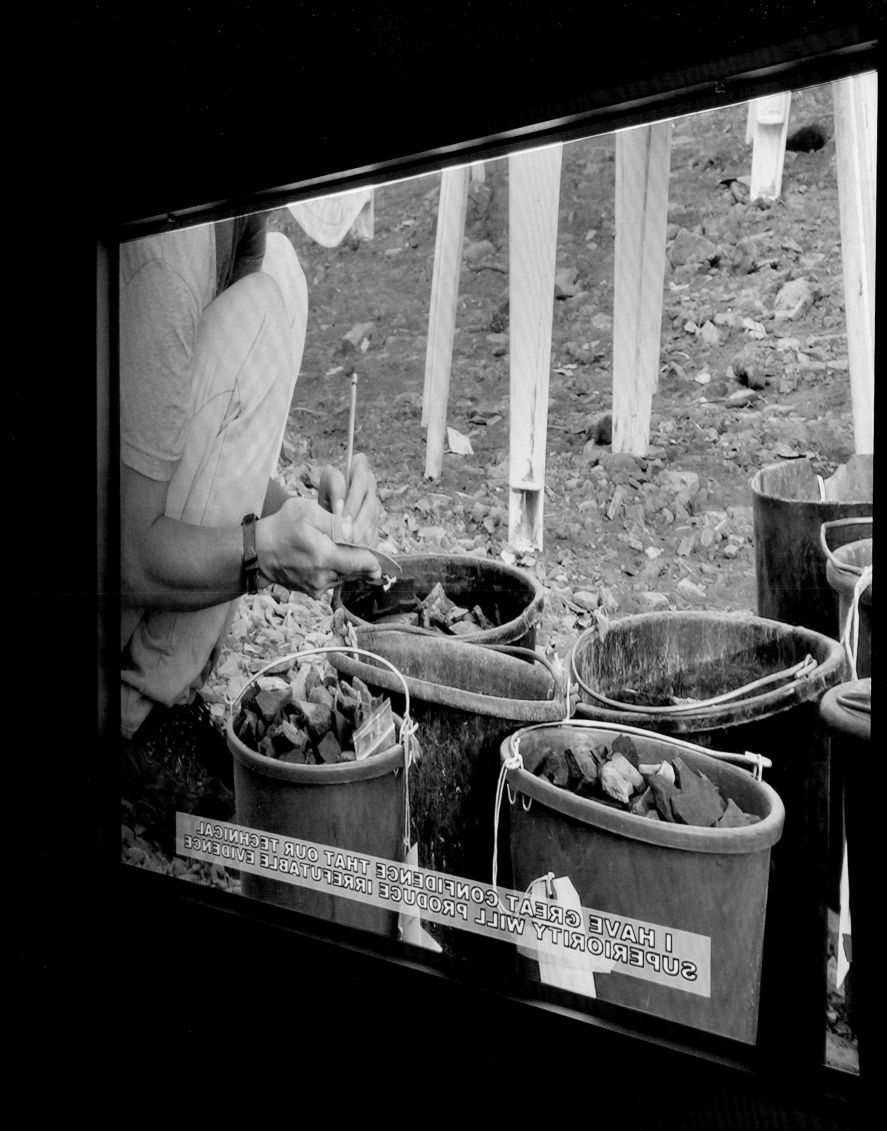

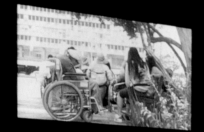
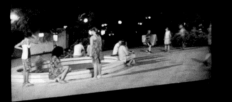

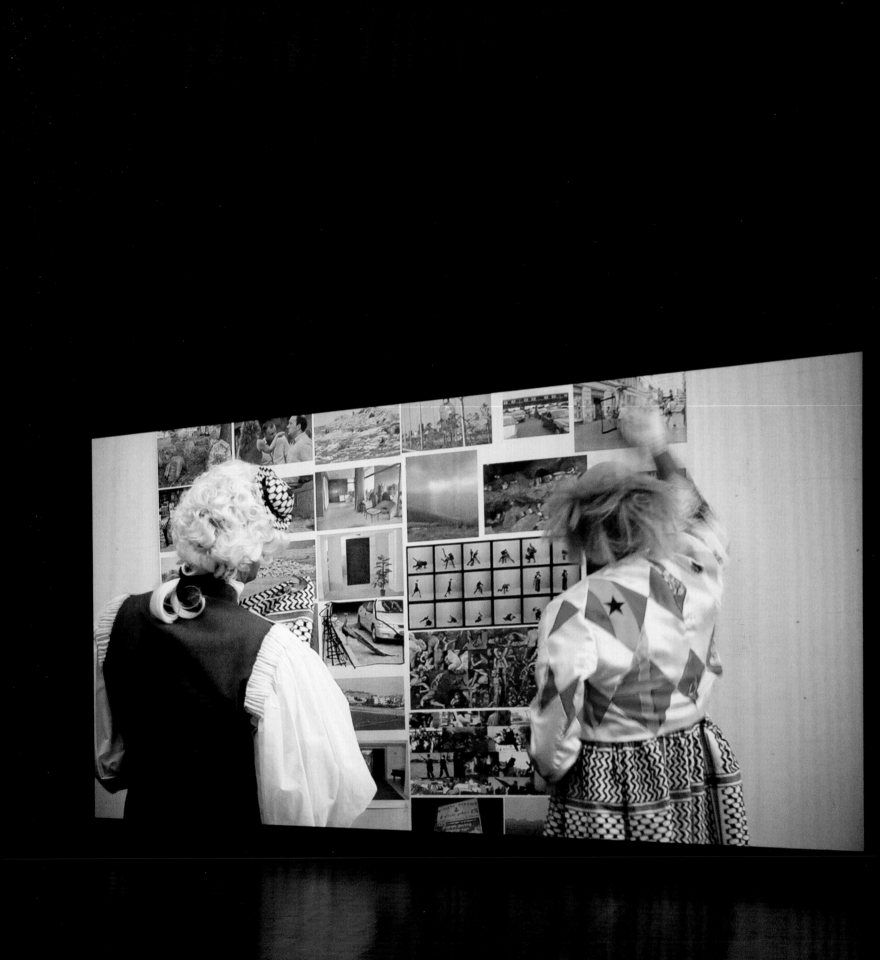

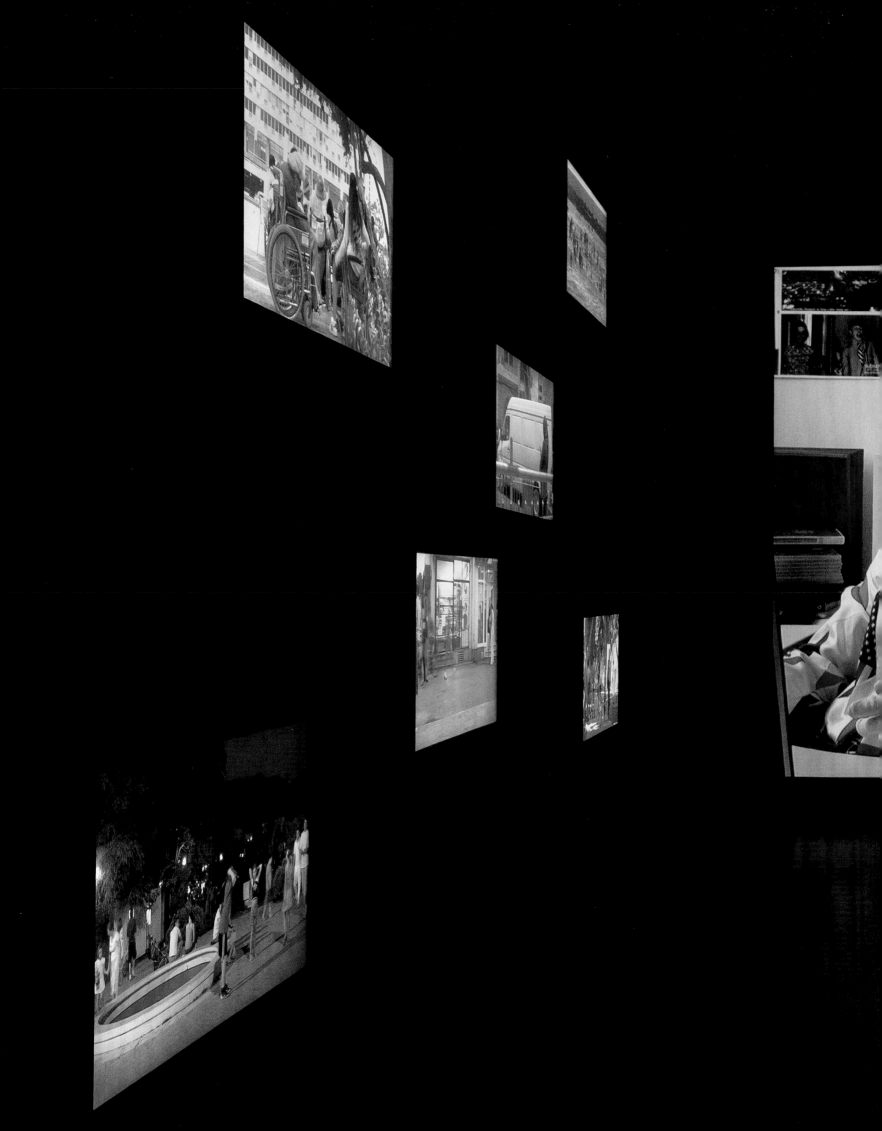

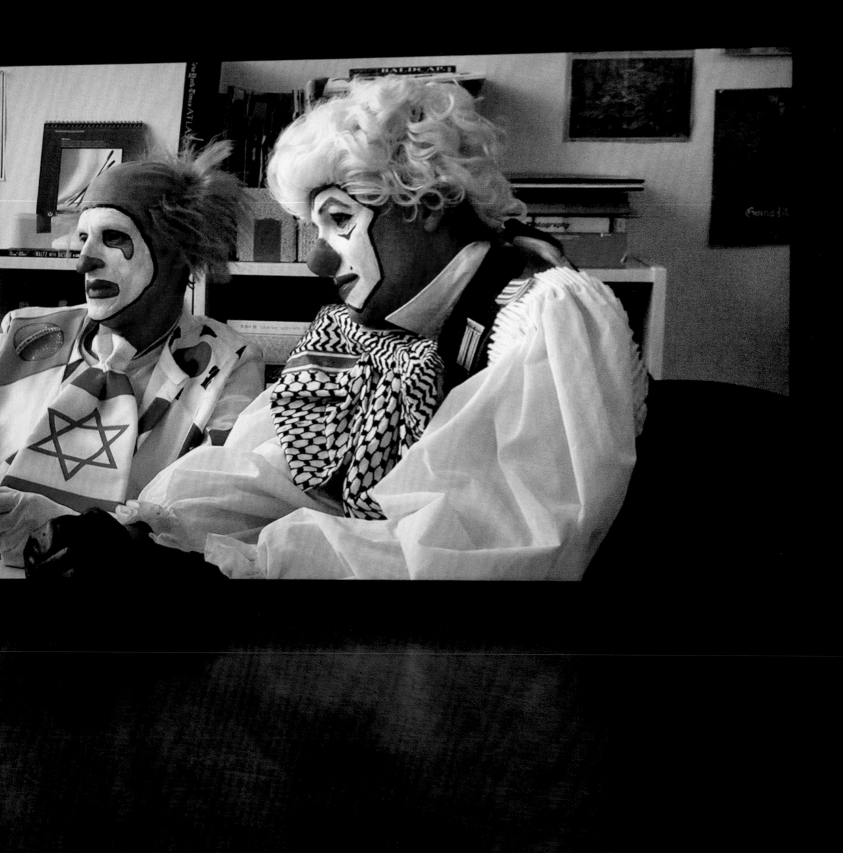

TAMI KATZ-FREIMAN

FROM BODY POLITICS TO CONFLICT POLITICS: AZIZ + CUCHER COME OUT OF THE (BIOGRAPHY) CLOSET

Like the pairs of foxes in the biblical story of Samson, tied together by their tails, a flaming torch between them, so Israel and the Palestinians—despite the imbalance of power—drag each other along. Even when we try hard to wrest ourselves free, we burn those who are tethered to us—our double, our misfortune—as well as ourselves.

David Grossman[1]

LICENSE: THE INSIDER

June 13, 2006: I am at the Haifa Museum of Art, concluding my lecture on "the demise of the aura" as theorized by Walter Benjamin. I thank the small group of people who made it to the museum, and express my surprise at their interest in attending a lecture that is so manifestly detached from the reality of their lives at that moment—of the missiles falling just thirty miles away from us in the north of Israel. As dusk falls, I leave the museum and catch a cab to the train station, where

I plan to take the train home to Tel Aviv. The harrowing sound of a loud explosion tears through the air. This missile, which exploded right by the Stella Maris Monastery—less than three miles away from the museum—was the first of the missiles that would explode in Haifa over the subsequent weeks. Following that traumatic moment, I did not return to the city until the end of the Second Lebanon War two months later, on August 14 figs. 44–45 . Due to an absurd coincidence of the kind typical of Israel's political conflicts, the museum building happened to be in the proximity of several Hezbollah targets. The artworks were all removed from the walls and put in storage in the building's basement, and the museum was temporarily closed to the public.

My choice to begin this essay with an account of this surreal wartime experience has to do with the fact that the invitation I received from Aziz + Cucher to contribute

to this catalogue is related not only to my significant involvement with their work over the course of many years, but also with my status as an "insider"—as one who was born into the ongoing conflict that we Israelis tend to refer to simply as "the situation"; I was chosen as one capable of reading their work from a perspective of familiarity, of placing it in the complex context of both the local and the international discourse on political art, and above all of mediating it to an audience that is not intimately familiar with the trials and tribulations of Middle-Eastern reality.

THE SECOND LEBANON WAR: A TURNING POINT
The Second War in Lebanon was an unexpected turning point in Aziz + Cucher's work—one that played a central role in bringing about the sweeping change that is given expression in their most recent body of work. Following

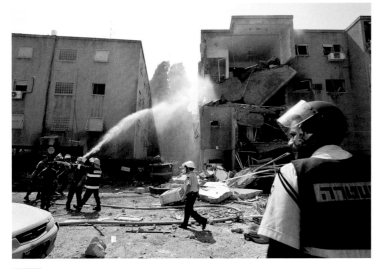

fig. 44

Rescue workers operating at the site of a building directly hit by a rocket fired from Lebanon in the northern Israeli city of Haifa, July 17, 2006
Photo by Baz Ratner. © 2012 The Associated Press

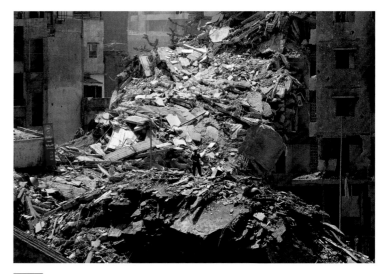

fig. 45

A man standing on the rubble of a building in the southern suburbs of Beirut, which was destroyed by Israeli forces during the 2006 Israeli-Hezbollah conflict, August 23, 2006
Photo by Matt Dunham. © 2012 The Associated Press

the outbreak of the war in the summer of 2006, the bubble surrounding this artist duo's concern with universal questions pertaining to the body and to identity suddenly burst; concrete, violent events began to undermine the emotional immunity that had previously prevented the intrusion of such elements into the iconography of their work. Up until that point, they were convinced that the personal aspects of their biographical identities—the fact that Sammy was raised as a Zionist and that his family lives in Israel, and that Anthony, who was born in the United States, has a large family in Lebanon—were irrelevant to their work. That summer, however, they were struck by the realization that they could no longer work at a distance from the events taking place in their lives, or maintain a barrier between their art and the emotional turmoil provoked by these events. As they wrote in their travel journal, "After witnessing first-hand the terror of

9/11 in our own city, and then the barrage of images of chaos and senseless violence unleashed by the US' catastrophic, misguided war in Iraq, the 2006 war seemed to be the capstone to a cycle of tragic and absurd inevitability. The unexpected suddenness of this war, and its hopeless display of destructive power on both sides, had an impact on our psyches and our souls that neither of us could have expected."[2]

The news from the war front triggered in them both an overwhelming sense of dread and despair that neither one had experienced previously. Even though Sammy's family was in no immediate danger of being hit by Hezbollah rockets, the two were overcome by a new sense of the fragility and vulnerability of life in Israel. At the same time, they were horrified by the asymmetrical violence that characterized the Israeli response to the Hezbollah attacks, and to the extent of the destruction wrought by

the Israeli army in southern Lebanon—as reported by Anthony's cousins via e-mail to his family in the US.

THE JOURNEY AND THE TRAP

Two years later, spurred on by the combined opportunity of an artist's residency and a sabbatical, Aziz + Cucher set off on a journey to the heart of the conflict in an attempt to connect, to hunt down relevant images, and perhaps also to reach a better, direct, and unmediated understanding of the region's complex and painful political reality. As one of their contact people in Israel, I received detailed lists of sites and themes that the two wanted to explore; I introduced them to key figures who would assist them in reaching Ramallah, in the West Bank, as well as in visiting the Israeli town of Sderot, in the vicinity of the Gaza Strip—the target of repeated missile attacks launched by Hamas.

To be perfectly honest, at that stage I doubted that this project would give rise to any visually meaningful result. In Israel, the complexity of the country's political state is often described as something that "strangers cannot grasp." There is an understanding of sorts that outsiders have no legitimate claim on making statements about it, and no license to address burning political issues. What, Israelis argue, can such outsiders possibly add to the hackneyed discourse of political art—especially given their lack of intimate familiarity with the tragic narrative in which we are trapped? And how, in any event, can one give visual expression to the complexity of this narrative and take a stance without falling into the familiar trap of politically engaged art, which reduces the conflict to a shallow protest against the Israeli occupation? Such protest, moreover—despite being justified and usually also photogenic—is

more often than not boring and clichéd. Furthermore, cashing in on the political injustices suffered by others for the purpose of achieving artistic success is in itself morally problematic. Aziz + Cucher shared my skepticism concerning the effectiveness of political art in general, and doubted their own ability to give visual expression to the complexity of the Israeli-Palestinian conflict, which is so painfully palpable in the lives of those living on both sides of the divide: "What could we possibly say or show that has not been said and shown before by countless other artists from the region, who have a much closer and legitimate relationship to the conflict? How can we address this 'black hole' of pessimism and thwarted hopes? How can we possibly give an aesthetic dimension to the carnage?"

THE BEAUTY OF THE CONFLICT

The moral questions concerning the seductive pull of the aesthetics of violence—questions raised by Aziz + Cucher's travel journal—occupy a central place in the discourse on political art. The problematic nature of representing violent conflicts and making them visible through the prism of various artistic filters, with an emphasis on the paradox inherent to the coupling of violence and aesthetics, has been examined by numerous artists and critical thinkers alike. Ever since the German-Jewish philosopher Theodor Adorno pronounced his famous injunction against representing the Holocaust in art ("To write a poem after Auschwitz is barbaric"),[3] artists have repeatedly returned to this subject, metaphorically banging their heads against the wall. Following the attack on the World Trade Center, important contemporary thinkers such as Slavoj Žižek (in his book *Welcome*

to the *Desert of the Real*) and Paul Virilio (in his book *Art and Fear*) examined the mesmerizing image of the collapsing towers. Both these thinkers attempted to get to the root of our fascination with this horrifying spectacle, arguing that terror and violence may indeed be aesthetic. The German composer Karlheinz Stockhausen even hastened to declare (later apologizing for this statement) that this harrowing moment was one of the most aesthetically powerful experiences in his life. Is it, indeed, even possible to discuss aesthetic values such as composition, line, rhythm, and color in the context of images of war and violence? What is the connection between the ethical and the aesthetic? Between morality and beauty? And what do such tragic events have to do with humor?

HUMOR AS STRATEGY

These fundamental questions were similarly raised during the various editing stages of *Some People*; indeed, the decision to avoid direct representations of violence related to the political conflict clearly reveals an awareness of the problematic nature of such images. The conflict itself—the ongoing state of war, the collective sense of despair, and the lack of any viable solution on the horizon—is perceived, in this context, as a metaphor. Their preoccupation with concrete events led Aziz + Cucher to a series of tragic (albeit also poetic and at times even comic) insights concerning life and the futility of such conflicts. This approach is most strikingly given expression in their self-reflexive work *By Aporia, Pure and Simple,* which occupies a central place in this project. Aziz + Cucher's decision to capture themselves in their studio, in the process of preparing the

exhibition, while dressed as two clowns—each wearing his own ridiculous "national" costume—underscores the absurd quality of their mission, and sarcastically alludes to its futility fig. 46. In this context, humor becomes a strategy of survival. The helplessness experienced vis-à-vis "the situation" is related by Aziz + Cucher to a recognition of their inability to confront the question of representing the conflict in a serious manner. In their own words, "It is the running gag in our routine: a clown making a foolish entrance in search of an evasive punch-line, walking the tightrope over a precipice of meaning. Juggling affections and positions like wands on fire, hoping that our souls won't get scorched, splitting ourselves into pieces by trying to see this land from all viewpoints at the same time. Tumbling right and left from one side to the other. Tiptoeing on an endless trek over the minefield of equanimity."

In Aristotle's terms, the clown walking the tightrope is the same *eirôn* (from which the word "irony" is derived) who detracts from his own value and from the value of his achievements in an exaggerated manner. The failures, fears, and mistakes highlighted in the course of his performance deflect our attention from the praiseworthy aspects of his work—his courage, precise maneuvering, and perfect coordination. The use of a tactic borrowed from the world of the circus—the lowest, most popular, and least cerebral of comic genres—underscores the collision between the use of crude comic elements and the emotional and dramatic themes examined in this work. The choice of a comic tactic—the clowning act performed in the studio—is related to the title of this work, which is borrowed from *The Unnamable,* a novel by Samuel Beckett. The narrator rhetorically asks himself: "How do you go on living?" and answers: "By Aporia,

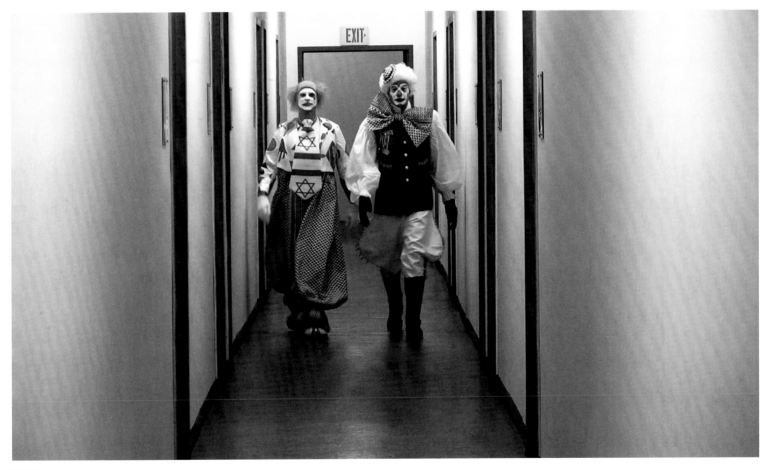

fig. 46

By Aporia, Pure and Simple, 2011
Video still
Single-channel HD video projection, six looped
DVD displays, surround sound, 8:43 mins.

pure and simple."[4] The word "aporia" has a typically Beckettian meaning, referring as it does to an irresolvable internal contradiction or disjunction. Indeed, dressed in their circus costumes, Aziz + Cucher are reminiscent of the two clown-like vagabonds waiting at the side of the road for the mysterious Godot to come and redeem them—to quell their inner turmoil, and perhaps even to resolve the conflict in the Middle East.

The representation of the creative process unfolding in the studio in the ironic format of "a day in the life of the artists," the emphasis on their frustration vis-à-vis the materials they collected in the course of their journey, the cacophonous music (a pastiche of interrupted radio transmissions from the region, combined with news reports in the American media), and the surreal rendition of a traditional Middle-Eastern folk dance that concludes the work—all come together to underscore the spirit of silliness that pervades this work, and which stands out in stark contrast to the tragedy of the conflict figs. 47–48.

THE POLITICS OF A DOUBLE / BIFURCATED IDENTITY: THE SHACKLES OF GUILT AND VICTIMHOOD

The artists' personal biographies were thus woven into the complex texture of the ongoing geo-political conflict in the Middle East. Whereas earlier works by Aziz + Cucher could be described as detached from any concrete reality, this project may well be defined as their "coming out" moment: as they appear center stage, attempting to come to terms with an all-too-familiar political reality, their personal biographies are interwoven, seeming to flood the work and further deepening the set of contradictions that define their identities. As they write in their travel journal, "Before I can say I, it must be said that this I is a divided self, but also multiplied,

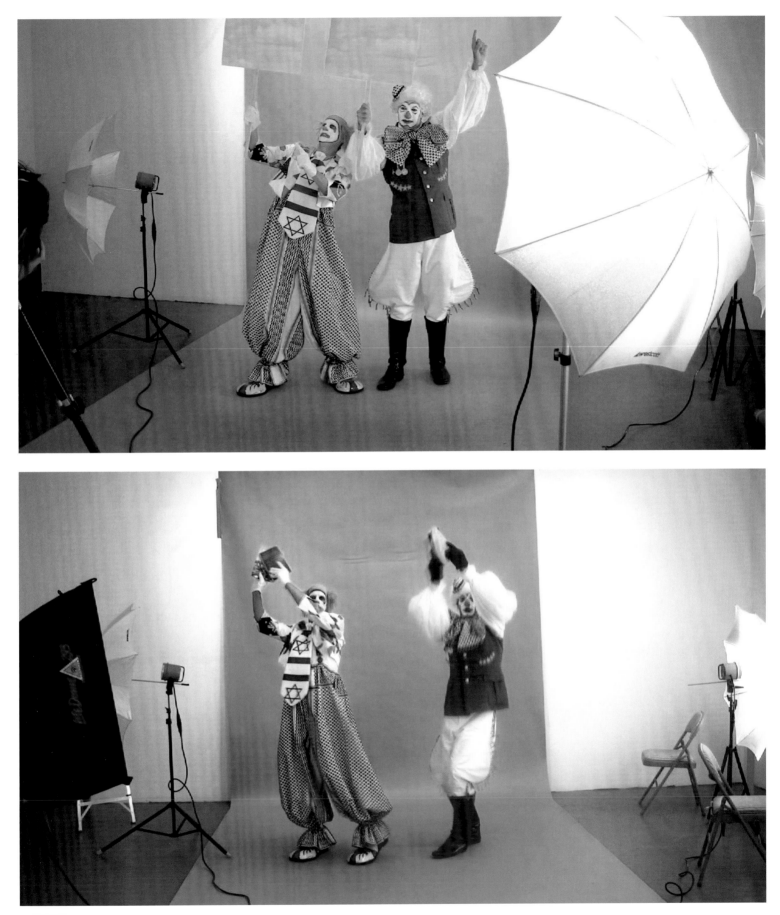

figs. 47–48

By Aporia, Pure and Simple, 2011
Video stills
Single-channel HD video projection, six looped
DVD displays, surround sound, 8:43 mins.

caught between a lifetime of intimacy and two lifetimes of experience alien to each other but destined to meet and converge in a landscape long longed for, filled with subtle aromas inherited from ancient grandmothers, where warring tribes repeat an endless story that seems to have been going through the same paces since a time older than memory itself."

Artistic collaborations raise fundamental questions concerning the manner in which decisions are taken and executed, since they are diametrically opposed to the myth of the solitary artist deliberating before an empty canvas. The preoccupation with identity, as complex as it may be, becomes ever more difficult when it involves the identities of two individuals who have been collaborating over the course of two decades. To make things even more complicated, the family narratives of these two artists unfold on opposite sides of the political divide. As I read their travelogue, which is written in the first person plural and constantly blurs the distinction between their individual identities, I attempt to crack the code of the "self," to unravel the knotted tangle that makes up this double identity and to stick to the politics of identity I am familiar with, which unfolds in the first person singular. I attempt to forge distinctions: to identify the experience of Anthony visiting his grandfather's house in Lebanon; to extricate from the plural form the singular combination of embarrassment and pride experienced by Sammy as he attends a military ceremony for his nephew's army troupe at the Western Wall in Jerusalem figs. 49–51. The bifurcation of identities that formed an inextricable part of this journey is aptly described by the two in the following excerpt from their journal: "I went. I and all my me's: the me that knows too much already and the me that knows nothing, really, the rootless me

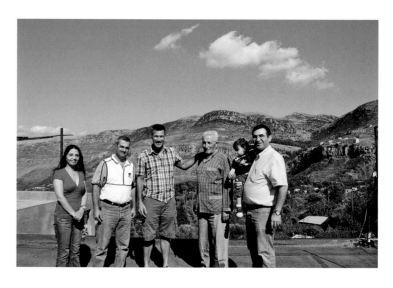

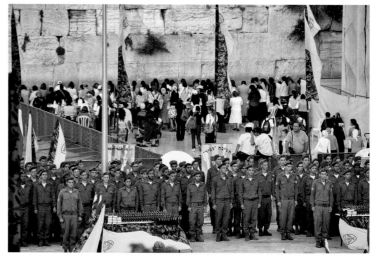

Top:
fig. 49
Anthony Aziz with his Lebanese cousins on the roof of his grandfather's house, overlooking the valley of Jezzine, Lebanon, October 2009
Photo by George Aziz, Jr.

Bottom:
fig. 50
The induction ceremony that included Sammy Cucher's nephew, in front of the Wailing Wall, Jerusalem, June 4, 2009

and the all-American me, the tropical mystical me and the northerly skeptical me, the brainwashed me and the subversive me: propelled by a wish to exorcise this anguish by breathing the supercharged air of these coasts and hugging the rugged terrain, and a wish to shed form on a formless void."

FROM THE SIMULACRUM TO THE REAL—FROM THE REAL TO THE ALLEGORICAL

Whereas in the past Aziz + Cucher's work could be defined as preoccupied with revealing the metaphorical pathologies associated with progress, with post-human conditions, and with the intersections between the social, the biological, and the technological, these concerns are virtually absent from the world of images that defines *Some People.* The attempt to trace the connection between these earlier works and the current project,

moreover, is far from simple. For by replacing their concern with the politics of the body with an examination of the hard core of the Israeli-Palestinian conflict, and by enlarging their field of vision from a concern with enigmatic, intimate aspects of the body to the conflicted and painful external reality of the Middle East, Aziz + Cucher have crossed all the lines that previously delimited the scope of their work. This sharp transition, as I would like to argue, may well be defined as the replacement of the simulacrum with the real. In 2002, in the context of an earlier exhibition, the two artists defined their lack of faith in the illusory manifestations of a so-called "truth": "As the eternal debate rages on about the appearance of truth and truth itself, simulation is the only truth we can trust."[5] As this statement reveals, their lack of faith in reality led them to consciously uphold the simulacrum as the only essence that could be trusted. Is it possible

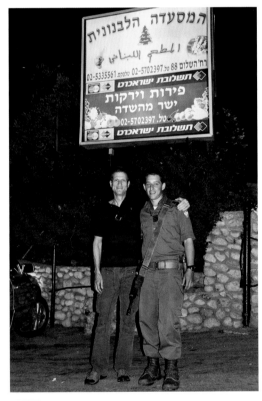

fig. 51

Sammy with his nephew, standing in front of a Lebanese restaurant in Abu Ghosh, Israel, June 4, 2009

that, in the course of their last journey, their faith was re-conquered by the power of the real?

One work that stands out in the context of their most recent body of works, and which may perhaps be seen as a link to earlier videos and digital prints, is the digital animation *Time of the Empress,* which is based on authentic architectural structures photographed in the course of their journey fig. 52. Through a labor-intensive process, the original images have been transformed into architectural drawings suspended in a cyclical loop of construction and dismantling, growth and dissolution, creation and destruction—like a series of Towers of Babel, simultaneously rising and collapsing as in a game of Tetris. The buildings were stripped of all identifying details, as well as of their background and original context, while volume and mass were translated into lines drawn in space. The soundtrack and constant movement allude to the Book of

Ecclesiastes: there is nothing new under the sun, history repeats itself, empires rise and fall, life is but vanity, and time is fleeting and ephemeral. The title of this work, meanwhile, refers to a passage from Marguerite Yourcenar's novel *Memoirs of Hadrian.* This allusion to the autobiographical monologue delivered by the Emperor Hadrian, which touches upon every aspect of human existence—with all of its complexity, changeability, internal contradictions, and dependence on the whims of the body in which it is contained—imbues this work with symbolic significance, and perhaps even serves as a key for understanding the rhetoric of the current exhibition as a whole.

Nevertheless, the replacement of the imagined with the real does not seem to have radically transformed the thought process and practice that define Aziz + Cucher's work. Like fragments of life transformed into poetry, the burning reality of the Middle East, that same reality

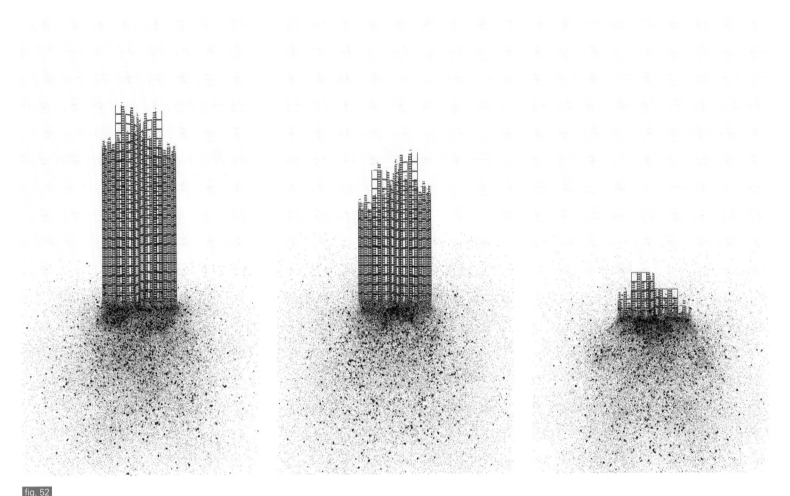

fig. 52

Time of the Empress, 2012
Video stills
Three-channel HD video loop,
stereo sound, 10:33 mins.

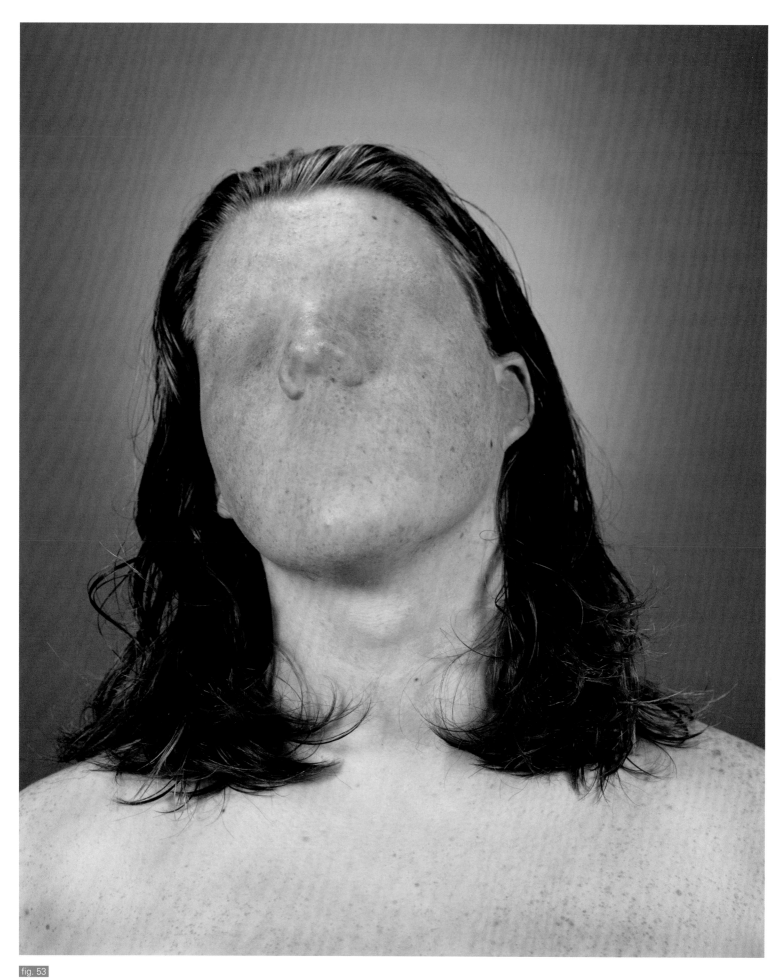

fig. 53

Rick from the *Dystopia* series, 1994–95
C-print, 50 x 40 in.

that was filmed and recorded in a given place at a given time, was processed and distilled through a great number of aesthetic and conceptual filters and strategies of mediation—cuts, doubling, and repetition—so that the resulting work exemplifies the long editing process to which the stuff of reality is subjected before it reaches the viewer in its final, perfectly orchestrated form.

The eccentric dance performance featured in the multichannel video work *In Some Country Under a Sun and Some Clouds* similarly attests to the manner in which the real becomes allegorical, while movement is transformed into a symbol. The epileptic-like movement of the dancers—who are trapped in a kind of knot against the background of an arid, rocky desert landscape—reminded me of the blindness, muteness, and deafness of the featureless figures that appeared in the earlier series *Dystopia* (1994–95) fig. 53. The dance they perform is

a choreography of paralysis, helplessness, and hesitation that bespeaks terrible vulnerability, wrought nerves, a state of terrible emotional turmoil, and fear of an external reality intruding inwards. The figures' disciplined body movements prevent them from exiting history or entering some kind of future, as they straddle the awkward divide between the comic and the tragic fig. 54.

The desolate desert terrain that serves as a background for these dancing figures contains numerous symbolic meanings, as a site representing various forms of mystification: to begin with, this is the landscape at the core of the Zionist ethos, which centers upon the conquest and re-cultivation of a seemingly uninhabited terrain. At the same time, this terrain, which is devoid of any clear center, symbolizes a state of exile, while its empty and barren expanse seems to impose a state of solitude on whoever enters it. The desert also has biblical

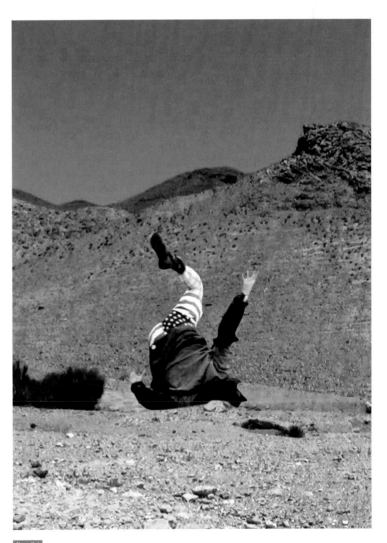

fig. 54
In Some Country Under a Sun and Some Clouds, 2012
Video still
Four-channel HD video projection, surround sound,
13:06 mins.

associations related to the formation of Jewish identity during the Israelites' forty-year-long journey to the Promised Land. The choice to locate these dancing figures in the physical and mental space of the nomad, and in the birthplace of the ancient Jewish Zealots, creates associations with extreme perceptual and bodily sensations—beauty, horror, and above all a paralyzing experience of frustration vis-à-vis the futility of endless bloodshed—as if the unease of being inside the body is united here with the sense of unease and desperation experienced vis-à-vis the current state of things—of existence itself as it is experienced in this part of the world.

THE ABSURD THEATER OF THE MIDDLE EAST

The existential world view, extreme pessimism, and sarcastic humor that are given expression in this body of works call to mind the rhetoric of Beckett's plays—the striving toward the essence of the self through a recognition of the nullity of human existence, and of man's entrapment in the endless, hopeless repetition of narratives centered on various forms of compensation and revenge. The static and robotic movement of the "dancers" in the desert echoes the movement that defines Beckett's theater of the absurd—a movement that is examined and studied allegorically in relation to an underlying state of immobility. The existence of the body, in Beckett's plays, is always defined through a state of lack or negation. Here too, the dancers' movements appear as a forced attempt to counter their inability to move—as an allegory for man's loss of control over his life, and an expression of his helplessness vis-à-vis the politics of injustice.

The perception of time in Aziz + Cucher's project is similarly reminiscent of Beckettian time, which is

AS IT STANDS NOW, THE OBJECTS IN QUESTION HAVE BEEN POSITIVELY IDENTIFIED AS SAFE

fig. 55
A Report from the Front, 2012
Video stills
Single-channel HD video, stereo
sound, 4:35 mins.

devoid of a chronological, linear structure. In the same way that *Waiting for Godot* is not a narrative account, but rather an in-depth examination of a static condition, so the "archaeologists," the "clowns" in the studio, and the "dancers" in the desert give expression to an externally imposed and endlessly repeated state of stasis that is entirely futile. The more things change, the more they remain the same: violence triggers further violence, which in turn triggers even more violence, and so on and so forth until the end of time—a state of existence imbued by the recognition that hope itself is nothing but the last illusion. As is the case in Beckett's work, here too the only attempt at redemption is the attempt to give expression to the experience of existence in words or in art—even though this attempt itself is doomed to fail.

TIME CAPSULE: ARCHAEOLOGY AS METAPHOR

The archaeological site featured in the video work *A Report from the Front* may be similarly read as an allegory that reveals the manipulative nature of the archaeological practice, and provokes thoughts about an archaeology of the future in the aftermath of an impending catastrophe. In this work, the absurd and futile quality grows even stronger, as does the sarcastic political stance of the artists both in relation to the Middle East and in relation to American mechanisms of control. In this work, Aziz + Cucher combined documentary footage from archaeological excavations in Israel (at Bethsaida, north of the Sea of Galilee—the site of an ancient Jewish settlement that was conquered by the Romans, and the birthplace of three of the apostles) with a fictional transmission that fuses authoritative police reports from real and imagined sites of disaster fig. 55.

AND WE MUST PROTECT AND ENFORCE THE COMMAND STRUCTURE TO ENSURE THAT THE TIMELINE

The Sisyphean work of the archaeologists digging into the ground to excavate various finds, which they then brush, wash, sift, gather, classify, and register—functions as a key visual axis in this work. These actions acquire a harrowing significance when viewed together with the soundtrack emitted from a series of loudspeakers, which addresses an invisible audience (journalists at a press conference?) as if in the aftermath of a military attack or nuclear disaster. Fragmented sentences such as "damage to the linking process," "last year's crisis of re-interpretation," "the objects are safe," "alert-level orange," "trans-historical contamination," or "the outcome of the intrusion of doubt" provoke a sense of horror combined with a ridiculous quality. The surreal narrative points toward a future Armageddon, and renders the question of ownership over the land manifestly irrelevant.

It is important to remember that in Israel, more than anywhere else in the world, archaeology is a key ingredient in the country's political hodgepodge. Pervaded as it is by national, ideological, and theological interests, archaeology plays a central role in public debates, while archaeological artifacts are exploited for different political purposes in a seemingly unprecedented manner. Early on in the history of Zionism, archaeology came to be perceived as an arena for forging a national identity, while Zionist mythology conscripted the biblical past into the service of both the present and the future. Over time, the purportedly sacred argument concerning the historical right of the Jewish people to build a national home in its land was sustained by determining the importance of archaeological finds according to their degree of compatibility with the biblical narrative. In recent years, the "new archaeologists" affiliated with post-Zionist thought have

begun to voice doubts concerning the historical value of biblical stories, which they view as no more than myths designed to endow the Jewish people with an impressive genealogy. At present, archaeology in Israel is no longer perceived as a romantic mission undertaken in the service of the Jewish people's national revival, but rather as a poignant parable for the contested claims underlying the present conflict.

In this context, Aziz + Cucher's engagement with archaeological practices may be viewed as an ironic strategy, which enables them to perceive the past as a reflection both of the present and of a catastrophic future. Archaeology allows them to move freely forwards and backwards in time—casting a reflexive gaze on a past surrounded by the aura of antiquity, and upon the political and ideological manipulation of archaeological vestiges in the service of national goals. Their disturbing fusion

of different historical periods—the allusion to the ancient rule of Tiglath-Pileser III or of the Cypro-Phoenician kingdom, alongside the use of contemporary terms and technologies (the UN decision concerning the foundation of the state of Israel, the cracking of the DNA code, chromosomes)—amplify the potential of a future catastrophe. The key sentence: "We must never forget: those who own history—own the land," raises various questions, and even perhaps a hidden hope—can the definitive identification of various artifacts indeed determine the fate of the conflict once and for all?

EPILOGUE: THE PERSONAL IS POLITICAL
The personal, biographical experiences related to the political events experienced by Aziz + Cucher in the course of their journey are codified through images, narrative fragments, strategies of hybridization, and various forms

of resonance and repetition—forming a language that enables them to move in the space between the political and the aesthetic. It seems that the statement "the personal is the political"—which may equally be rephrased as "the political is personal"—aptly sums up the current body of works: the physical presence of these two artists and their personal stories take center stage for the first time, while appearing alongside themes and images culled from a conflicted public sphere. It seems that the prism through which Aziz + Cucher observe the Israeli-Palestinian conflict is a universal prism—one that provides a view of the human condition, and which places the local conflict in the global context of life in the age of terror.

Albert Camus aptly expressed this existential sense of absurdity in "The Myth of Sisyphus": "In a universe suddenly divested of illusions and lights, man feels an alien, a stranger. His exile is without remedy since he is deprived of the memory of a lost home or the hope of a promised land. This divorce between man and his life, the actor and his setting, is properly the feeling of absurdity."[6] Indeed, despite the concrete, real quality of the characters featured in this project—the artists themselves disguised as clowns, the self-conscious young soldiers participating in a military ceremony, or the men and women working on an archaeological excavation—they are all transformed from actual people into abstract representations of ideas and symbols. It seems that the principle of the absurd, which rules the violent trap into which the local conflict has fallen, has disrupted the possibility of a coherent narrative or sense of place, divesting these figures of their biographical stories; as a result, this principle itself is transformed into the protagonist of the allegory represented in this project.

Finally, a couple of words about the title of this exhibition, which was borrowed from a poem by the Polish

poet Wisława Szymborska that begins: "Some people fleeing some other people. / In some country under the sun / and some clouds."[7] These lines are almost comical, projecting the image of crudely drawn hordes of tiny human beings fleeing across a vast expanse of earth, while their fate is determined by forces greater and more powerful that any one individual. This poignant image of displacement, flight, and fear, and the description of small, insignificant human gestures in the face of terrible uncertainty, inspired Aziz + Cucher to take the first steps toward the creation of this project.

But I have chosen to conclude with an excerpt from another poem by Szymborska, which is titled "Children of Our Age"—a text which reveals that a commitment to live in our conflicted world inevitably condemns individuals to a "political life":

We are children of our age,
it's a political age.

All day long, all through the night,
all affairs—yours, ours, theirs—
are political affairs.

Whether you like it or not,
your genes have a political past,
your skin, a political cast,
your eyes, a political slant.

Whatever you say reverberates,
whatever you don't say speaks for itself.[8]

Essay translated by Talya Halkin

1 "Gaza Success Proves Israel Is Strong, Not Right," *Haaretz,* January 20, 2009.
2 All statements by Aziz + Cucher are quoted from their travel journal and from the blog they wrote during and after this journey. See http://azizcucher.blogspot.com/2009_05_01_archive.html.

3 Theodor Adorno, "Cultural Criticism and Society," *Prisms,* trans. Samuel and Shierry Weber (Cambridge, 1967), p. 19.
4 Samuel Beckett, *The Unnamable* (New York, 1970), p. 3.
5 Aziz + Cucher as quoted in my essay for the brochure accompanying their solo exhibition *Passage* at the Herzliya Museum for Contemporary Art, Israel, June 2002.

6 Albert Camus, "The Myth of Sisyphus," *The Myth of Sisyphus and Other Essays,* trans. Justin O'Brien (New York, 1958), p. 6.
7 Wisława Szymborska, "Some People," *Miracle Fair,* trans. Joanna Trzeciak (New York, 2001), p. 55.
8 Wisława Szymborska, "Children of Our Age," *View with a Grain of Sand: Selected Poems,* trans. Stanisław Barańczak and Clare Cavanagh (New York, 1995), p. 149.

RICHARD MEYER

"VERY BAD CLOWNS": AN INTERVIEW WITH ANTHONY AZIZ AND SAMMY CUCHER

RICHARD MEYER I'm currently co-teaching a graduate seminar called "Contemporary Art in the World: A Global Itinerary." It comes out of a certain frustration with all the talk about globalization in the art world, but the relative lack of attention to the conditions of what life is like on the ground for contemporary artists in specific locales, whether that's Dakar or Lahore or, for that matter, East Los Angeles. So we're looking at concrete sites of production rather than at globalization theory per se. And so my first question for you is, why was it important for you to go to Israel, Lebanon, and the former Yugoslavia for the work in *Some People*?

AZIZ + CUCHER Even though we had both been to Israel before, we had never been there together with the idea

of making work about the place, so it was important to go there with a more purposeful (collaborative) eye. This was a research trip with the sole purpose of collecting images, stories, interviews, audio recordings, and emotions that would be used as a poetic foundation for understanding our relationship to the Middle East. We went to Croatia, Bosnia, and Serbia because we have always been fascinated by the music and films of the region—especially films by Emir Kusturica (director of *Underground* and *Black Cat, White Cat*), which have a mixture of irony and dark humor that we felt was quite appropriate for the kind of language we were trying to discover in this new body of work. We thought that going there would add a new perspective to our understanding of ethnic conflict. We specifically wanted to visit the city of Sarajevo because of

its cosmopolitan history of co-existence between Christians, Jews, and Muslims. More than anything, it was an irrational attraction that led us there.

MEYER In terms of "irrational attractions," can we talk about the use of costume, make-up, and theatricality in *By Aporia, Pure and Simple* `fig. 56`? By theatricality, I'm thinking specifically of artifice that draws attention to itself as such rather than attempting to render a seamless illusionism. Different techniques of theatricality seem to me a hallmark of your work going back to the *Dystopia* series of 1994–95. I'm thinking here of your use of scale, color, and the "rubbing out" or spectacular eliding of bodily orifices to comment on post-human conditions at the time. The theatricality of the current work seems to function in a quite different way—not hopeful, exactly, but humorous and at times almost humanist. I also want to think about the way that the theatricality insists both on the importance of the fact of your traveling to the Middle East and the impossibility of knowing what it is "really like" to be there.

AZIZ + CUCHER The idea of the clown costumes for *By Aporia* came out of the desire to literally wear our contradictions on our sleeves and to expose our own feelings of insufficiency in addressing such overt tribal or nationalistic affinities. We both feel deeply implicated and at the same time confounded by the urge to define a clear identity based on familial and ideological upbringings.

We saw ourselves performing a comical role as artists trying to make sense of our own emotional distress resulting from recent geo-political events and how they directly affect our shared sense of powerlessness in relation to this ongoing conflict.

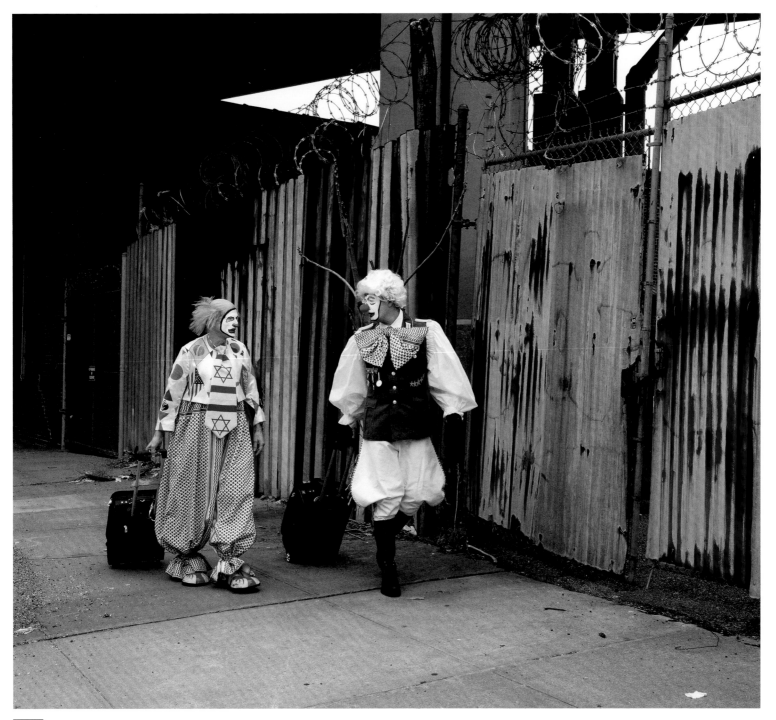

fig. 56

1 from the *Aporia* series, 2012
Light-jet print, 50 x 72 in.

If indeed there is a theatricality in our earlier photographic work, it came out of our understanding of gesture and body language that we appropriated from established visual genres codifying gender, power, and identity. But rather than a theatrical strategy, we thought of it as a kind of fictionalized representation of the body.

In *By Aporia,* we are creating a self-portrait for the first time, and that imposes an inevitable humanism on the process. Earlier, we were interested in making a commentary on society at large; in this new work, it is only us, and our own specificity, which are caught in the conundrum of history.

MEYER One of the things that interests me most about the works in *Some People*—and here I'm thinking especially of *By Aporia* and *A Report from the Front*—is the way in which location is put into question: framed and reframed, placed and displaced. So for example, we see both video and photographic footage taken in the Middle East that you are working on in your studio in New York. We see you dressed as hilariously costumed clowns—each with powdered wigs, satin ties, and symbols representing his ethnic or religious identification— even as we also see you as a collaborative team working together and walking down the street past MoMA PS1 in Queens fig. 57. We hear about the war in the Middle East on the radio and we see pictures, but they are mediated through the distance of photography, video, and clownish farce.

In *A Report from the Front,* the report issues from a site of archaeological excavation (rather than of military combat). So it's never a straightforward claim that you guys are making to be documenting the reality of the war in the Middle East. And this, paradoxically, is what

makes the work effective as a response to something that would otherwise seem virtually impossible for artists to address.

AZIZ + CUCHER One of the biggest challenges when we took on this project was how to deal with the issues metaphorically. We all live with a constant barrage in the media of graphic images about war and violence in the Middle East, which paradoxically have desensitized us to the human dimension of the conflict. As artists, it is impossible to compete with the spectacle of the media, but it is possible to attempt to create a poetic vision that depends more on allusion and nonlinear thinking, rather than on fidelity to a documentary truth. If you were to take out the narrative soundtrack from *A Report from the Front,* you would end up with fairly conventional documentary footage of an archaeological dig, but by

superimposing this sort of science-fictional report on it, it displaces the reality of the excavation, but at the same time brings up loaded questions about territory and history that would not otherwise be visible. These strategies of framing and re-framing are the essential tools of our poetic thinking, and they also allow us to build layers of narrative complexity that we hope reflect the layers of geo-political and existential complexity that characterize life in the midst of conflict.

MEYER I want to return to something you said earlier that I am only now coming to grips with. You said that in *By Aporia* you were creating a self-portrait for the first time. This seems like an important statement both about your preceding work and about this piece. I guess I'd never understood the absence of self-images in your earlier work as a self-conscious choice or withholding.

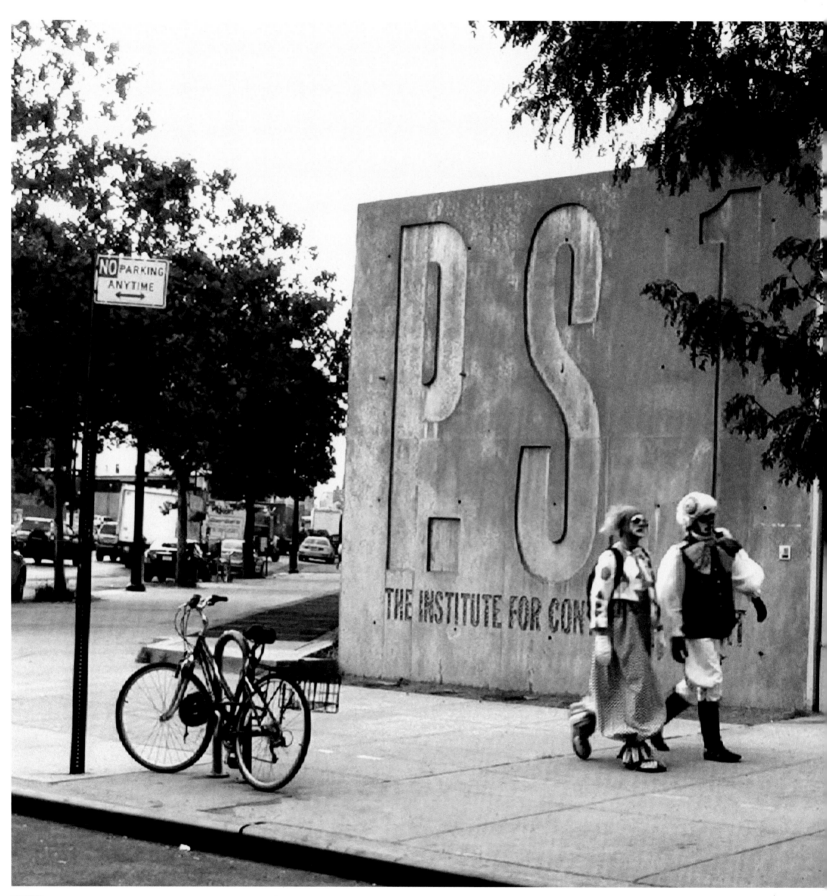

By Aporia, Pure and Simple, 2011
Video still
Single-channel HD video projection,
six looped DVD displays, surround
sound, 8:43 mins.

Indeed, I don't think I knew for sure that there were no extant self-portraits of Aziz + Cucher prior to the current work. So, can we talk about the absence of self-portraiture until now, and the decision to delve into it in this particularly theatrical manner in *By Aporia*?

AZIZ + CUCHER Sure. Right from the start in 1992, we felt that through collaboration we could overcome the tired mythology of the individual artist struggling to unravel his ego through artistic expression. And so we embraced the position that even though the work was filtered through our subjective individualities, it was ultimately a response to the world outside and not about us, so therefore we deliberately did not include our own image in the work.

In 2006, we realized we could no longer ignore our profound attachments to the Middle East. But it was only later during the process of making the work that we realized we had to put ourselves in the work so as to make it our own, and not a mere appropriation of someone else's struggle. By doing so, we felt downright clownish; the foolishness of even trying to address conflict as a subject matter led us inevitably to portray ourselves in this way. It seemed entirely appropriate and even necessary to expose the extraordinary pitfalls involved in such an effort.

We feel it is important to point out, however, that we are not "acting" in this piece; rather we are just going about our day, *in drag.* Yes, it was set up shot-by-shot, but we are not attempting to theatrically portray anything other than who we are and what we do. The fact is, we make for very bad clowns.

MEYER I think that's what makes the piece so effective—the disconnect between the outrageous pomp of the

costumes and the cool dispassion with which you comport yourselves while wearing them. It seems important, too, that you do actually "wear" your own cultural affiliations on your costumes, with the Star of David emblazoned on Sammy's wide, wide tie and Anthony's *keffiyeh* wrapped into an oversized bow. I'm wondering, though, whether being a "very bad clown" isn't also an appropriate response to (or embodiment of) the failure of contemporary art to address the most pressing social and political conditions of our moment.

AZIZ + CUCHER It was never our intention to make any sweeping commentary about the state of contemporary art, vis-à-vis society and politics, but rather to laugh at our own deeply felt sense of inadequacy. However, it does seem sometimes that a lot of contemporary art is content to merely exist in an insular bubble of formalism or an empty repertoire of post-conceptual gestures. At the same time, there are a lot of artists working individually and in collectives who are embarking on a kind of art-activism that seeks to redefine the boundaries of art and politics, but in the bargain, this type of work seems to lose all sense of metaphor and the possibility for addressing these things from a poetic perspective. While we have not always worked directly with social and political issues, the works in *Some People* come from the same impulse that lead to the very first project we made together in 1992, *Faith, Honor and Beauty*. It came out of an urgency to respond to the absurdities of the culture wars, the controversy over decency in art and queer visibility. We felt compelled to address this matter not so much because we felt censored as artists, but because it seemed at the time to embody a great betrayal of the founding principles and civil liberties of our society.

MEYER Let's talk about the origins of your collaboration in the context of San Francisco and the culture wars. When I met you guys (which was way back then) we were all necessarily thinking a lot about the censorship of homoerotic art in the context of the AIDS crisis and the conservative attacks on the NEA [National Endowment for the Arts]. The Robert Mapplethorpe retrospective that had been canceled by the Corcoran in June 1989 traveled the following year to Berkeley; Gran Fury's "Kissing Doesn't Kill: Greed and Indifference Do" poster appeared on San Francisco city buses and muni trams (after having been defaced throughout Chicago), and local chapters of the activist groups ACT UP and Queer Nation were extremely visible at the time.

One of the things that strikes me about your early 1990s work (and I'm thinking of both *Faith, Honor and Beauty* and *Dystopia*) is the way in which censorship has become literalized on the surface of the body, as though the body itself were being sutured closed by the prohibitions imposed upon it. At the same time, and cutting against this dystopian effect, is a sort of photographic sublime in terms of color and scale. Can we discuss the ways in which you were thinking about form and content in relation to the culture wars at the time?

AZIZ + CUCHER It is true. Living in San Francisco in the early '90s, it was impossible not to be influenced by the circumstances that you describe; however, in our first project at [the alternative art space] New Langton Arts, *Faith, Honor and Beauty,* we chose to appropriate the rhetoric of the mainstream "other" and take it to its illogical extreme instead of insisting on the aggressive representation of the queer body fig. 58. This required, of course, that we not just censor but *over-censor* the

figures, and in the process of turning them into inflated Barbie and Ken dolls, we also rendered them comical and powerless in spite of their scale and hyper-perfection. The color palette and the realism of the representation came directly from marrying patriotic themes with the visual language of advertising. Additionally, we did extensive research into the relationship between art and totalitarianism as it found expression in the 1930s and '40s in Germany and later in the USSR.

The motivation behind the disappearance of the facial features in *Dystopia* is quite different, but not completely unrelated to issues around censorship. We were deeply concerned about the increasing dependence on new technology and its disruptive threat to traditional social space and ways of communication; this trope of technological domination over mind and body is also portrayed in many well-known works of science

fiction that imagine societies under a techno-totalitarian control.

Furthermore, fear of disappearance is traditionally discussed along with ideas of the sublime in psychoanalysis, but in truth we only discovered this as something relevant to our project after we made the first images and were astonished by their power. As for the larger-than-life scale of the *Dystopia* portraits, we wanted to exacerbate the paradoxical tension between the lack of individual features and an overwhelming sense of humanity.

MEYER I'm struck by the large insignia / banners that were hanging at the entrance to *Faith, Honor and Beauty* at New Langton Arts in 1992 fig. 59. Already in this first collaboration there is an address to the pageantry of power but also, in a sense, to its absurdity, since the

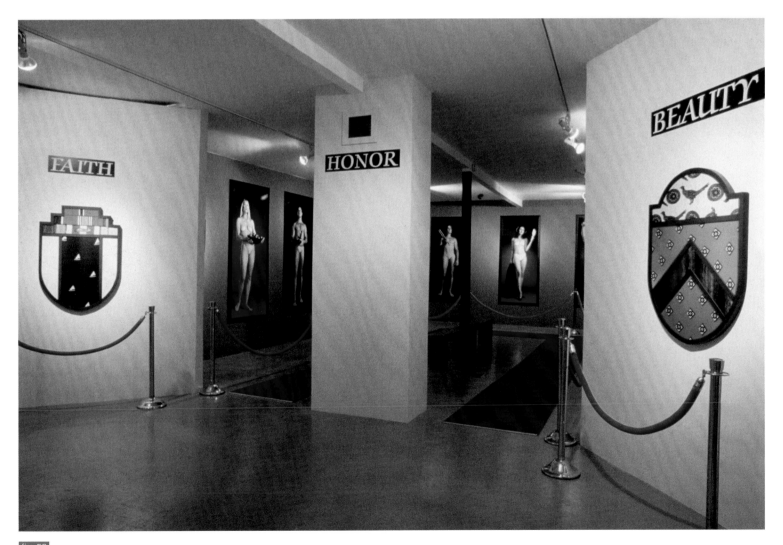

fig. 58

Faith, Honor and Beauty, 1992
As installed at New Langton Arts, San Francisco

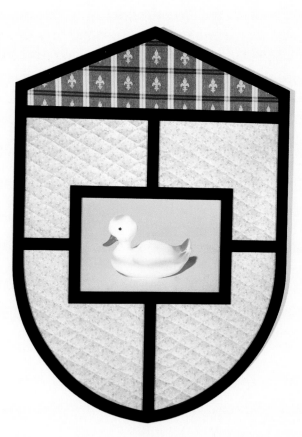
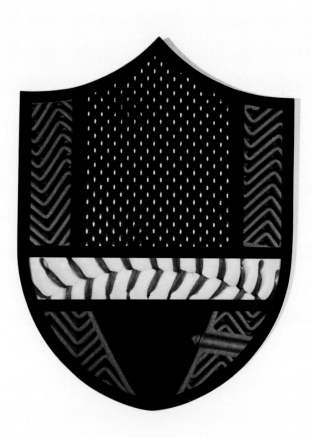

pictures in the show hardly accord with conventional ideals of faith, honor, and beauty.

AZIZ + CUCHER With the heraldic shields, we were adding to the deconstruction of the symbology of power by putting these very common surfaces and objects into an exalted form. It was an ironical stance which has not always been present in our work, but which has come to the surface from time to time—for example, in the prints of the *Naturalia* series figs. 60–61, which appropriated the visual vocabulary of natural history illustration—and most recently in *A Report from the Front* and *By Aporia, Pure and Simple.*

MEYER One of the things that doesn't seem ironic to me about *By Aporia*—notwithstanding the clown suits—is the fact that it is a portrait of a couple. I met you guys shortly after the two of you got together in 1991 and here we—and more importantly here the two of you—are, twenty-one years later. So I see the work as a highly crafted self-portrait of a middle-aged queer couple who are working at the intersection of video art, performance, and photography but also within the context of their own long-term relationship and ongoing day-by-day dialogue.

AZIZ + CUCHER Yes, the fact that we have reached, as you say, *middle age,* has perhaps given us the freedom to look at ourselves with more humor and not to take ourselves so seriously, throwing caution to the wind. Whatever intimacy or tenderness between us that comes through in this piece was never in any way planned but is very much the inevitable result of us spending virtually every moment of every day together for the past twenty-one years, "in sickness and in

fig. 59

Faith, Honor and Beauty, 1992
Crests
Laminated C-prints with custom
bent-wood frames, dimensions
variable, each approx. 40 x 30 x 2 in.

Following pages:
figs. 60–61
N13-Plate XCII and *N12-Plate VIIa*
from the *Naturalia* series, 2000
Giclée print on Somerset Paper, each
20 x 16 in.

FICHTER'S FIBRONECTIN-q LINEAGE

Ig domains

Hinge

Fibronectin domain

N

ssd
N-CAM

sd
N-CAM

id
N-CAM

Ng-CAM

C

MAG

C

C

crystallic cystomeres
(224.763.992.0.000.1)

Organ of Prung

vagus

sacrus

altius

fortius

*Unibrachial
Specimen*

alambroid with constrictor
(443.886.000.0.113.8)

Diplocydic Compund Reaction

PLATE XCII
Inverted Jacksonoid
almagraf.mitsubishi@ffg.bio

non-plestogenic ORMUDS[TM] *tissue*
(662.545.887.9.000.4)

nodal zones of psychoactive interaction (II.2.1)

Frigg's rupture

schematics of Ingwert's method

His$_{12}$

RNA

His$_{119}$

E

CH$_2$ Base$_1$

diffuses out

OH

-O-P=O

OH

E

CH$_2$ Base$_2$

O-P

-O

E

electropathic emotion diagram

mhz÷hi$_\phi$

pap

ξ

68

ϕ sic

57

κ^2

ecto

35

τ

nup

26

π''

sed

12

η

0

silicobacteric glass
(964.999.343.5.221.1)

Rings of Bugli
655mfd/sec

branchiadic growth

orthogenic configuration of
celluloblasts

Pachydoteric Junction

PLATE VII.a

described in Grets: *Onomanomerics of the P-cycle*
sts/hvlt~45@hua.bio

ng: on ratio-blood

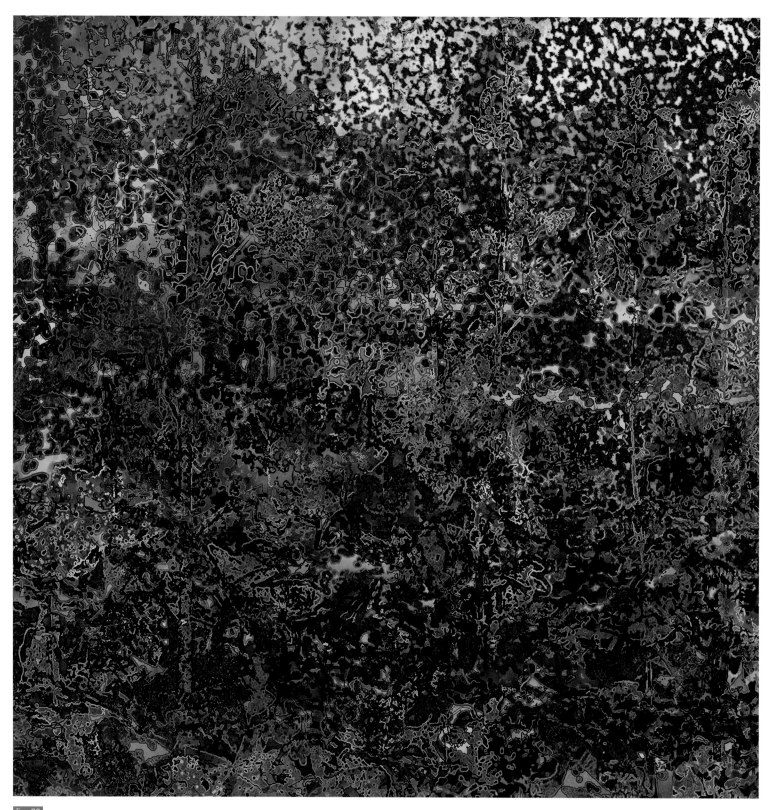

fig. 62

SB_Oda # 4, 2005
Light-jet Endura Metallic print with
aluminum mount, 24 x 24 in.

health," enduring the ups and downs and bumps and turns of living an unconventional life as artists.

MEYER Great. I think the interview is basically over. But I do have one more question to ask. I heard that you guys "left" the art world for a while, and I was wondering if you'd be willing to discuss the circumstances of this departure with me.

AZIZ + CUCHER We did not exactly leave it as much as take a detour. In 2005, our Chelsea gallery closed its doors, and soon after we received an unusual commission from a collector who invited us to create an exquisite hand-knotted carpet based on one of our prints at the time, which represented nature abstracted through a digital lens figs. 62–65. The work was done in Nepal, and it led to an amazing opportunity to develop a relationship

with a workshop in Kathmandu, which then went on to produce a small collection of unique hand-woven rugs. For a while, we moved away from our fascination with pixels and virtuality and set our gaze on this ancient tradition of handcraft. But already by 2006, our interest in land and landscape shifted toward a more political direction, which culminated in the creation of *Some People*.

fig. 63
Cobra, 2006
Hand-woven carpet
As installed at the Mertel-Druker residence, New York

fig. 64
Cobra, 2006
Hand-woven carpet
Level-cut Himalayan wool and Chinese silk pile, 12 x 9 ft.

fig. 65

Field # 5 from the *Scenapse* series, 2007
Light-jet Endura Metallic print with Diasec
mount, 50 x 72 in.

SOME PEOPLE
CREDITS

Time of the Empress, 2012
Three-channel HD video loop, stereo sound, 10:33
minutes
Animator: Ed Purver
Architectural draftsman: Danny Greenfield
Sound design / acoustics: Larry Buksbaum

In Some Country Under a Sun and Some Clouds, 2012
Four-channel HD video projection, surround sound, 13:06
minutes
Composer / sound design / acoustics: Larry Buksbaum
Choreography consultants: Maya Lipsker and Pedro
Osorio
Performers: Asli Bulbul, Julian De Leon, Cynthia Cortes
Di Lena, Alex Escalante, Maya Lipsker, Amanda Loulaki,
Pedro Osorio, Kayvon Pourazar, Fabio Tavares
Costume design: Beto Guedes
Green screen production and post-production: Bravo
Studios, New York
Digital compositing assistant: Umut Ozover
Production assistant: Martin Parsekian

A Report from the Front, 2012
Single-channel HD video, stereo sound, 4:35 minutes
Text: Aziz + Cucher
Sound design / acoustics: Larry Buksbaum
Special thanks to Professor Rami Arav, Director of the
Bethsaida Excavation Site, Israel

By Aporia, Pure and Simple, 2011
Single-channel HD video projection, six looped DVD dis-
plays, surround sound, 8:43 minutes
Principal camera: Kate Riedl
Additional camera: Rayna Savrosa
Costume design and fabrication: Yashi Tabassomi
Hair and make-up: Anthony Pepe
Sound collage: Aziz + Cucher
Sound mix: Larry Buksbaum
Special thanks to Amir Galijasevic, Manal Mahamid,
Diana Shoef of CCA / Tel Aviv

AZIZ + CUCHER

Collaborating since 1992

ANTHONY AZIZ
American, * 1961
Boston College, Boston (BA), 1983
San Francisco Art Institute, San Francisco (MFA), 1990

SAMMY CUCHER
American, * Lima, Peru, 1958
Tisch School of the Arts, New York University,
New York (BFA), 1983
San Francisco Art Institute, San Francisco (MFA), 1992

AWARDS, GRANTS, AND RESIDENCIES

2009
Berlin Residency, C-Collection Development Grant,
Vaduz, Liechtenstein
Koopman Distinguished Chair in the Visual Arts, Hartford
Art School, University of Hartford, Connecticut

2007
Faculty Development Fund, Parsons The New School for
Design, New York

2004
Project Support Grant, Etant Donnés, The French-
American Fund for Contemporary Art, New York

2003
Digital Media Grant, New York Foundation for the Arts, New York

2002
Artist's Grant, The Pollock-Krasner Foundation, New York

1996
Ruttenberg Award, Friends of Photography, San Francisco

1993
John D. and Susan P. Diekman Endowed Fellowship, Djerassi Resident Artists Program, Woodside, California

1992
Project Development Grant, Art Matters, New York

1991
Regional Fellowship Award, The Western States Arts Federation (WESTAF), National Endowment for the Arts (NEA), Washington

SOLO EXHIBITIONS

2012
Aziz + Cucher: Some People, Indianapolis Museum of Art (IMA), Indianapolis, Indiana

2009
Aziz + Cucher: Guest Project, Sultan Gallery, Kuwait City

Aziz + Cucher, National M.K. Čiurlionis Art Museum, Kaunas, Lithuania

2008
Aziz + Cucher, Stiftelsen 3,14, Bergen, Norway
Scenapse: New Photography, CLAMPART, New York; Galería Trama, Barcelona
The Linked Ring, Joseloff Gallery, Hartford Art School, University of Hartford, Hartford, Connecticut

2006
Interiors and *Synaptic Bliss,* Artereal Gallery, Sydney

2005
Synaptic Bliss, Galería Trama, Madrid; Barcelona

2004
Synaptic Bliss_Villette, Villette Numérique 2004, Parc de la Villette, Paris

2002
Passage, Herzliya Museum of Contemporary Art, Herzliya, Israel

2001
New Work, Éspace d'art Yvonamor Palix, Paris
Recent Work, Henry Urbach Architecture, New York

2000
Series 96:00, Museo Alejandro Otero, Fundación Museos Nacionales (FMN), Caracas

1999
Aziz + Cucher, Museo Nacional Centro de Arte Reina Sofia, Madrid

1998
Aziz + Cucher, Reali Arte Contemporanea, Brescia, Italy
Aziz + Cucher: Unnatural Selection, Frances Wolfson Gallery at Miami Dade College, Miami

1997
Aziz + Cucher, Les Rencontres d'Arles, Arles, France
Plasmorphica, Jack Shainman Gallery, New York

1996
Aziz + Cucher, Kemper Museum of Contemporary Art, Kansas City, Missouri
Aziz + Cucher: Unnatural Selection, The Photographers' Gallery, London; Photology, Milan
New Work, Éspace d'art Yvonamor Palix, Paris

1995
Dystopia, Jack Shainman Gallery, New York
Venice Biennale, Venezuelan Pavilion, Venice

1993
Faith, Honor and Beauty, Jack Shainman Gallery, New York

1992
Faith, Honor and Beauty, New Langton Arts, San Francisco

SELECTED GROUP EXHIBITIONS

2012
Do or Die: The Human Condition in Painting and Photography; Teutloff meets Wallraf, Deutsches Hygiene-Museum, Dresden, Germany
Fairy Tales, Monsters, and the Genetic Imagination, Frist Center for the Visual Arts, Nashville, Tennessee
Unnatural, Bass Museum of Art, Miami Beach

2011
Altered States, FOLEYgallery, New York
Beauty Culture, Annenberg Space for Photography, Los Angeles
Cabaret, Galeria Ramis Barquet, New York
Down to Earth, Gazelli Art House, London
Paradesign, San Francisco Museum of Modern Art (SFMOMA), San Francisco
Reconceptualizing Vision, PingYao International Photography Festival, Pingyao, China
So, Who Do You Think You Are? San Jose Museum of Art, San Jose, California

2010
Changing the Focus, Museum of Latin American Art (MOLAA), Long Beach, California
Degrees of Separation: Contemporary Photography from the Permanent Collection, San Jose Museum of Art, San Jose, California
Do or Die: The Human Condition in Painting and Photography; Teutloff meets Wallraf, Wallraf-Richartz-Museum, Munich
Skin, Wellcome Collection, London

2009
Arcadia, CLAMPART, New York
Genipulation, Centre PasquArt, Biel, Switzerland
Huesped, Museo Nacional de Bellas Artes (MNBA),
Buenos Aires
Sensate, San Francisco Museum of Modern Art
(SFMOMA), San Francisco

2008
246 and Counting: Recent Acquisitions, San
Francisco Museum of Modern Art (SFMOMA),
San Francisco
Passageworks: Contemporary Art from the Collection,
San Francisco Museum of Modern Art (SFMOMA),
San Francisco

2007
À travers le miroir, Musée d'art et d'archéologie,
Aurillac, France
Digital Portraits, CLAMPART, New York
Double Vision, Deutsche Bank, New York
In the Dermisphere, Art Center College of Design,
Pasadena, California
Jump Cuts, Cisneros Fontanals Art Foundation (CIFO),
Miami
Second Skin, Museum of Contemporary Art
(MOCATapei), Taipei

2006
*A Curator's Eye: The Visual Legacy of Robert A.
Sobieszek,* Los Angeles County Museum of Art
(LACMA), Los Angeles

Contemporary Art Reflecting Medicine, Kustmuseum
Ahlen, Ahlen, Germany
Future Face, National Taiwan Museum of Fine Arts
(NTMOFA), Taichung, Taiwan
Photo España 2006, Madrid
Second Skin, Entry 2006 Expo, Essen, Germany
What a Great Space You Have, Luxe Gallery, New York

2005
Arti e Architettura: 1900–2000, Palazzo Ducale, Genoa,
Italy
Jump Cuts, Americas Society / Council of the Americas,
New York
La Peau est ce qu'il y a de plus profond, Musée de
Beaux-Arts Valenciennes, Valenciennes, France
Perdere la testa, Lattuada Studio, Milan
Synaptic Bliss, Eyebeam Art and Technology Center,
New York

2004
Future Face, Science Museum, London
LOOP International Video Art Fair, Barcelona
Making Faces, Musée de l'Elysée, Lausanne, Switzerland
Paradise Now: Picturing the Genetic Revolution,
University of Maryland, Baltimore, Maryland
Photography and the Death of the Portrait, Hayward
Gallery and Visual Arts, Southbank Centre, London

2003
Cara à Cara, Culturgest, Lisbon
*Chimères, monstres et merveilles, de la mythologie aux
biotechnologies,* Musée des Beaux Arts, Monaco

Only Skin Deep: Changing Visions of the American Self,
International Center of Photography, New York
Rethinking Photography V, Forum Stadtpark, Graz, Austria
Undomesticated Interiors, Smith College Museum of Art,
Northampton, Massachusetts

2002
Bewitched, Bothered, and Bewildered, Migros Museum,
Zurich
Body Design, San Francisco Museum of Modern Art
(SFMOMA), San Francisco
Human Park, Palau de la Virreina, Barcelona
Latent Space, Netherlands Architecture Institute,
Rotterdam
Out of Site: Fictional Architectural Spaces, New Museum
of Contemporary Art, New York
Skin: Surface, Substance, and Design, Smithsonian
Cooper-Hewitt National Design Museum, New York
Skin Talks, Musée de la civilisation, Quebec City, Canada
The Other Face, Deutsches Museum, Munich
Unexpected Selections, The Margulies Collection at the
Warehouse, Miami

2001
Brooklyn, Palm Beach Institute of Contemporary Art
(PBICA), Palm Beach, Florida
Face Off, Aeroplastics Contemporary, Brussels
Flesh and Fluid, CCS Bard Center for Curatorial Studies
at the Hessel Museum of Art, Annandale-on-Hudson,
New York
Organic / Inorganic, San Francisco Museum of Modern
Art (SFMOMA), San Francisco

Paradise Now: Picturing the Genetic Revolution,
The Frances Young Tang Teaching Museum and Art
Gallery at Skidmore College, Saratoga Springs,
New York
Photography Biennale, Turin, Italy
Réjouissez-Vous! Centre d'Art, Le Parvis Scène Nationale
Tarbes-Pyrénées, Ibos, France
Sense of Space, Noorderlicht Photofestival, Groningen,
the Netherlands
Terrors and Wonders, deCordova Sculpture Park and
Museum, Lincoln, Massachusetts

2000
Made in California: Art, Image, and Identity, 1900–2000,
Los Angeles County Museum of Art (LACMA), Los Angeles
Sharing Exoticism, La Biennale de Lyon, Lyon, France
The Anagrammatical Body, Center for Art and Media
(ZKM), Karlsruhe, Germany

1999
Braga Photo Festival, Braga, Portugal
*Ghost in the Shell: Photography and the Human Soul,
1850–2000,* Los Angeles County Museum of Art
(LACMA), Los Angeles
One Hundred Years of Art in Germany, Neue
Nationalgalerie, Berlin
Out of Portrait, Galerie Georges-Michael Kahn,
Strassburg, France
The Anagrammatical Body, Kunsthaus Mürzzuschlag,
Graz, Austria
Triennale der Photographie Hamburg, Deichtorhallen,
Hamburg

1998

Art and Genetic Engineering, Galerie Rudolf Mangisch,
Zurich
Fotobienal de Vigo, Vigo, Spain
Hygiene, Éspace d'art Yvonamor Palix, Paris
Magritte and Contemporary Art, Museum of Modern Art
(PMMK), Ostend, Belgium
Maschile Femminile, Palazzo Abatellis, Palermo, Italy
*Photography's Multiple Roles: Art, Document, Market,
Science,* Museum of Contemporary Photography,
Chicago
The Male Image, Wessell and O'Connor Fine Art,
New York

1997

Esto Es: Recent Latin American Art, El Centro Cultural de
Mexico, Mexico City
Le Mois de la Photo à Montréal, Montreal
Love Hotel, National Gallery of Australia, Canberra,
Australia
The New Face, Kunstverein Konstanz, Konstanz,
Germany

1996

Double vie, Double vue, Fondation Cartier pour l'art
contemporain, Paris
Family, Nation, Tribe, Community SHIFT, Haus der
Kulteren der Welt; Neue Gesellschaft für Bildende Kunst
(NGBK), Berlin
Fotobienal de Vigo, Vigo, Spain
Non! Pas Comme Ça! Centre d'Art Neuchâtel (CAN),
Neuchâtel, Switzerland

Pixel Perfect, San Jose Museum of Art, San Jose,
California
*Prospect '96: An International Survey of Contemporary
Art,* Frankfurter Kunstverein, Frankfurt am Main
Version 2.2: Image et texte et informatique, Saint-Gervais
Genève, Geneva

1995

Bit-by-Bit: Post-Photographic Imaging, Hunter College,
New York
Obsessions: From WunderKammer to Cyberspace,
Rijksmuseum Twenthe, Enschede, the Netherlands
Photography After Photography, Siemens
Kulturprogramm, Munich
The New Child, Berkeley Art Museum, University of
California (BAM / PFA), Berkeley, California

1994

Fotobienal de Vigo, Vigo, Spain
Mirror, Mirror, San Jose Institute of Contemporary Art,
San Jose, California
Second Nature, Friends of Photography / Ansel Adams
Center, San Francisco
*The Ghost in the Machine: Anthony Aziz + Sammy
Cucher, Keith Cottingham, Kenjiro Okazaki + Yoshinori
Tsuda, Jeff Wall, Susan Gamble + Michael Wenyon,* List
Visual Arts Center, MIT, Cambridge, Massachusetts
Un homme et son image, Dazibao, Montreal

1993

The Final Frontier, New Museum of Contemporary Art,
New York

C-Collection, Vaduz, Liechtenstein
Colección Patricia Phelps de Cisneros, New York and Caracas
Collection Banque et Caisse d'Épargne de l'État (BCEE), Luxembourg
Denver Art Museum, Denver, Colorado
Fonds National d'Art Contemporain (FNAC), Paris
Fonds Régional d'Art Contemporain (FRAC), Auvergne, France
Galería de Arte Nacional, Caracas
Indianapolis Museum of Art (IMA), Indianapolis, Indiana
Kölnischer Kunstverein, Cologne, Germany
Los Angeles County Museum of Art (LACMA), Los Angeles
Maison Européenne de la Photographie, Paris
Musée de l'Elysée, Lausanne, Switzerland
Museo Alejandro Otero, Fundación Museos Nacionales (FMN), Caracas
Museo de Arte Contemporáneo de Castilla y León (MUSAC), Leon, Spain
Museo Nacional Centro de Arte Reina Sofia, Madrid
Museum of Contemporary Photography, Chicago
National Gallery of Australia, Canberra, Australia
Ruttenberg Foundation, Chicago
Sammlung Berger Foundation, Amorbach, Germany
San Francisco Museum of Modern Art (SFMOMA), San Francisco
San Jose Museum of Art, San Jose, California
The Margulies Collection at the Warehouse, Miami
Teutloff Photo and Video Collection, Bielefeld, Germany

2012
Aziz + Cucher: Some People. Edited by Lisa D. Freiman. Exh. cat. Indianapolis Museum of Art. Ostfildern, Germany, 2012.
Baler, Pablo. "Interrupted Reading: The Aesthetics of Metastasis." *The Next Thing: Art in the 21st Century.* Lanham, Maryland, 2012.
Fairy Tales, Monsters, and the Genetic Imagination. Edited by Mark W. Scala. Exh. cat. Frist Center for the Visual Arts. Nashville, Tennessee, 2012.
Sheets, Hilarie M. "It's an Absurd World, so Send in the Clowns." *The New York Times,* April 25, 2012.

2011
Flach, Sabine and Sigrid Weigel, eds. *WissensKünste: The Knowledge of the Arts and the Art of Knowledge.* Weimar, Germany, 2011: pp. 196–217.
Liu, Chu-Lan. *Arts Magazine* 437 (October 2011): pp. 290–97.
Marien, Mary Warner. *Photography: A Cultural History.* 3rd ed. Upper Saddle River, New Jersey, 2011.
Sheets, Hilarie M. "Dynamic Duos." *ARTnews* (February 2011).

2010
Do or Die: The Human Condition in Painting and Photography; Teutloff meets Wallraf. Edited by Andreas Blühm. Exh. cat. Wallraf-Richartz-Museum. Munich, 2010.
Wolf, Sylvia. *The Digital Eye: Photographic Art in the Electronic Age.* Munich, 2010.

2008

Aletti, Vince. "Critics Notebook: Train Your Gaze." *The New Yorker,* May 26, 2008.
Heartney, Eleanor. *Art and Today.* New York, 2008.

2007

Angier, Roswell. *Train Your Gaze: A Practical and Theoretical Introduction to Portrait Photography.* Lausanne, Switzerland, 2007.
Barth, Malin. *No Magazine* (March 2007).
"Interviews: Aziz + Cucher." *Daylight and Architecture* 5 (Spring 2007).

2006

Aziz + Cucher. Edited by Cay Sophie Rabinowitz. Exh. cat. Artereal Gallery. Sydney, 2006.
Bloch, Ricardo. *Philosophie Magazine* (November 2006).
Dillon, Brian. *Tate Etc,* 8 (Autumn 2006).
Li, Zhen. *Vision Magazine* (September 2006).
Wegenstein, Bernadette. *Getting Under the Skin: Body and Media Theory.* Cambridge, Massachusetts, 2006.

2005

Lipkin, Jonathan. *Photography Reborn: Image Making in the Digital Era.* New York, 2005.

2004

Anker, Suzanne. *The Molecular Gaze: Art in the Genetic Age.* New York, 2004.
Kemp, Sandra. *Future Face: Image, Identity, Innovation.* London, 2004.

Marien, Mary Warner and William Fleming, eds. *Fleming's Arts and Ideas.* 10th ed. New York, 2004.

2003

Chimères, monstres et merveilles, de la mythologie aux biotechnologies. Edited by Didier Ottinger. Exh. cat. Musée des Beaux Arts. Monaco, 2003.
Exit 11 (Fall 2003).
"Fotograf." *Journal of New Photography* (Summer 2003).
Karafyllis, Nicole Christine. *Biofakte. Versuch über den Menschen zwischen Artefakt und Lebewesen.* Paderborn, Germany, 2003: pp. 50–52.
Matador vol. G (Madrid, 2003).
Only Skin Deep: Changing Visions of the American Self. Edited by Coco Fusco. Exh. cat. International Center of Photography. New York, 2003.
Traub, Charles and Jonathan Lipkin. *In the Realm of the Circuit: Computers, Art and Culture.* Upper Saddle River, New Jersey, 2003.
Undomesticated Interiors. Exh. cat. Smith College Museum of Art. Northampton, Massachusetts, 2003.

2002

Benthien, Claudia. *Skin: On the Cultural Border between Self and World.* New York, 2002.
Lucie-Smith, Edward. *Art Tomorrow.* London, 2002.
Out of Site: Fictional Architectural Spaces. Edited by Anne Ellegood. Exh. cat. New Museum of Contemporary Art. New York, 2002.
Skin: Surface, Substance, and Design. Edited by Ellen Lupton, Jennifer Tobias, et al. Exh. cat. Smithsonian Cooper-Hewitt National Design Museum. New York, 2002.

Trajekte: Zeitschrift des Zentrums für Literatur- und Kulturforschung Berlin (April 2002).

von Brauchitsch, Boris. *Kleine Geschichte der Fotografie.* Stuttgart, 2002.

Williams, Gregory. "Critics' Picks." *Artforum* (Summer 2002).

2001
Gilmore, Jonathan. *Aziz + Cucher.* Tema Celeste (March 2001).

Hunt, David. "Reviews." *Flash Art* (June 2001).

Israel, Nico. "Reviews." *Artforum* (March 2001).

Paradise Now: Picturing the Genetic Revolution. Edited by Marvin Heiferman and Carole Kismaric. Exh. cat. The Frances Young Tang Teaching Museum and Art Gallery at Skidmore College. Saratoga Springs, New York, 2001.

Pollack, Barbara. "Reviews." *ARTnews* (June 2001).

2000
Ewing, William A. *The Century of the Body: 100 Photoworks 1900–2000.* London, 2000.

Kozloff, Max. "The Hive of Subtlety." *Aperture* 160 (Summer 2000).

MacAdam, Barbara A. "A Salon for the 21st Century." *ARTnews* (May 2000).

Vergine, Lea. *Body Art and Performance: The Body as Language.* 2nd ed. Milan, 2000.

Ward, Frazer. "Cumulus." *Parkett* 60 (December 2000).

"What is Beauty?" *Beaux Arts* (Summer 2000).

1999
ARTnews (May 1999), p. 138.

Aziz + Cucher: Recent Work 1998–99. Exh. cat. Galerie Lutz Teutloff. Bielefeld, Germany, 1999.

Rush, Michael. *New Media in Late 20th-Century Art.* London, 1999: p. 186.

Squiers, Carol, ed. *Over Exposed: Essays on Contemporary Photography.* New York, 1999.

1998
Andersson, Cecilia, "Tirando la (simil) Pelle." *Tema Celeste* (January 1998).

Attias, Laurie. "Hygiene," *frieze* 42 (September / October 1998): p. 92.

Colors 25 (April / May 1998): p. 93.

"Freizeit Digital." *Spiegel Special* 3 (1998).

Nixon, Mignon. "After Images." *October* 83 (Winter 1998).

Wood, John. *The Virtual Embodied: Presence, Practice, Technology* (London, 1998): cover.

1997
Cash, Stephanie. *Art in America* (December 1997): p. 91.

"Doppelgängerin aus Frankensteins Computer." *Der Spiegel,* February 8, 1997.

European Photography 62 (Fall / Winter 1997).

Goldberg, Vicki. "Photos That Lie—and Tell the Truth." *The New York Times,* March 16, 1997.

Lutyens, Dominic. "Aziz + Cucher." *Dazed and Confused* 26: p. 16.

1996
art kaleidoscope (February / March 1996): p. 9.

Aziz + Cucher: Unnatural Selection. Edited by Patrick Roegiers and Fabrizio Caleffi. Exh. cat. Photology. Milan, 1996.

Double vie, Double vue. Edited by Patrick Roegiers.
Exh. cat. Fondation Cartier pour l'art contemporain.
Paris, 1996.
KUNSTFORUM International (Winter 1995–96): cover.
Le Monde, June 21, 1996, Paris: p. 27.
The Independent, September 12, 1996.
ZEITmagazin, March 8, 1996: p. 32.

1995
Aletti, Vince. *Village Voice,* June 6, 1995.
Cooper, Emmanuel. *Fully Exposed: The Male Nude in
Photography.* 2nd ed. London, 1995: p. 254.
Hagen, Charles. *The New York Times,* June 16, 1995.
*Identity and Alterity: Figures of the Body 1895 / 1995;
La Biennale di Venezia, 46. Esposizione Internazionale
d'Arte.* Exh. cat. 46th Venice Biennale. Venice, 1995.
Le Monde, October 4, 1995.
SEE: A Journal of Visual Culture 1 (Winter 1995).
Times Literary Supplement, June 30, 1995: cover.
Zimmer, William. *The New York Times,* October 22,
1995: p. 16.

1994
*The Ghost in the Machine: Anthony Aziz + Sammy
Cucher, Keith Cottingham, Kenjiro Okazaki + Yoshinori
Tsuda, Jeff Wall, Susan Gamble + Michael Wenyon.*
Edited by Ron Platt. Exh. cat. List Visual Arts Center, MIT.
Cambridge, Massachusetts, 1994.

CONTRIBUTORS

LISA D. FREIMAN is senior curator and chair of the department of contemporary art at the Indianapolis Museum of Art. During her tenure at the IMA, Freiman has actively commissioned, collected, and exhibited the work of emerging and established artists, transforming the role of contemporary art in Indianapolis and creating a widely renowned contemporary art program. Freiman was selected to be the US Commissioner for the 2011 Venice Biennale, for which she worked with the artists Allora & Calzadilla to implement six new commissions for the exhibition titled *Gloria,* which was accompanied by a catalogue of the same name. Freiman has published extensively on contemporary art, including the books *Amy Cutler; María Magdalena Campos-Pons: Everything Is Separated by Water;* and *Type A.* She is currently editing the first collection of Claes Oldenburg's writings from the 1960s.

TAMI KATZ-FREIMAN is an art historian, curator, and critic based in Miami, Florida, where she works as an independent curator. Between the years 2005–10 she served as the chief curator of the Haifa Museum of Art in Israel. She has curated numerous group and solo exhibitions in prominent museums in Israel and the US, where she lived and worked between 1994 and 1999. From 2008–10 she was teaching at the Department of Art History at Tel Aviv University and at the International Curatorial Studies Program of the Kalisher Art School in Tel Aviv. She has published extensively in books, catalogues, and magazines devoted to contemporary art in Israel and abroad.

RICHARD MEYER teaches art history at the University of Southern California, where he also directs The Contemporary Project, a multi-year initiative to open up new dialogues between the academy and the art world. He recently completed two books: *What Was Contemporary Art?,* a short history of contemporary art in the first half of the 20th century to be published in 2013, and a co-edited volume with Catherine Lord titled *Art and Queer Culture.* In 2011, he guest curated the exhibition *Naked Hollywood: Weegee in Los Angeles* at The Museum of Contemporary Art in Los Angeles.

This book is published in conjunction
with the exhibition:

Aziz + Cucher: Some People

Indianapolis Museum of Art, Indianapolis
April 13 – October 21, 2012

Generous support provided by the Elizabeth Firestone
Graham Foundation

Editor: Lisa D. Freiman, IMA
Managing editor: Emily Zoss, IMA
Director of publishing and media: Rachel Craft, IMA
Manager of publications and photography:
Tascha Horowitz, IMA
Assistant photo editor: Julie Long, IMA
Curatorial assistant: Amanda York, IMA
Permissions: Anne Young, IMA
Translation of Katz-Freiman essay: Talya Halkin
Copyediting: Sandra-Jo Huber, Hatje Cantz
Graphic design: Anja Lutz // Book Design
Production: Katja Jaeger, Hatje Cantz
Reproductions: Jan Scheffler, prints professional
Typeface: Univers
Paper: Galaxi Supermat, 170 g / m^2
Printing and binding: DZA Druckerei zu Altenburg GmbH

Published by:
Hatje Cantz Verlag
Zeppelinstrasse 32
73760 Ostfildern
Germany
Tel. +49 711 4405-200
Fax +49 711 4405-220
www.hatjecantz.com

You can find information on this exhibition and many
others at www.kq-daily.de.

Hatje Cantz books are available internationally at selected
bookstores. For more information about our distribution
partners, please visit our website at www.hatjecantz.com.

ISBN 978-3-7757-3386-1

Printed in Germany

Front cover illustration: *# 2* from the *Aporia* series, 2012
Endpapers: Photographs taken at the Kunsthistorisches
Museum, Vienna; images from *Some People*; images of
conflict from news broadcasts
Exhibition photography by Hadley Fruits and Katelyn
Harper, IMA
All other images courtesy of Aziz + Cucher unless
otherwise specified